Images of Modern America

LGBTQ COLUMBUS

Images of Modern America

LGBTQ COLUMBUS

KEN SCHNECK AND SHANE McCLELLAND

ARCADIA
PUBLISHING

Published by Arcadia Publishing
Charleston, South Carolina

Printed in the United States of America

Library of Congress Control Number: 2018968202

For all general information, please contact Arcadia Publishing:
Telephone 843-853-2070
Fax 843-853-0044
E-mail sales@arcadiapublishing.com
For customer service and orders:
Toll-Free 1-888-313-2665

Visit us on the Internet at www.arcadiapublishing.com

*Dedicated to the LGBTQ community of Columbus who fought,
shouted, wrote, marched, and celebrated to create what we have today*

CONTENTS

274

ACKNOWLEDGMENTS

"Oh! You should talk to . . . " was the theme of this book. Every LGBTQ and ally champion in Columbus led us to another one, who said we absolutely must to speak to another one, who gave us directions to another one, and so on and so on. Compiling these photographs and narratives was the most incredible game of gay history dominoes ever played.

The phenomenal folks employed over at the Ohio History Connection supported the creation of this book to an indescribable degree. This would not be in your hands without them. From Tutti Jackson's first e-mail inviting us in, to Eric Feingold's archival skills and passion, to Lily Birkhimer's extraordinary assistance, patience, and flexibility, to Ben Anthony's wonderful connections, they (and all those who work with them) do not get enough acclaim for all that they are doing daily to preserve our history.

Though there are dozens of photographers represented in the book, you will see the names of Ray LaVoie, Ralph Orr, and Emma Parker pop up over and over again. The remarkable skill that these three have with their respective lenses is only matched by their extreme generosity in giving us access to their images. We are so appreciative.

Clevelanders Brian DeWitt and Doug Braun again came to the rescue as they did for the *LGBTQ Cleveland* edition: sharing photographs, granting access to old issues of *Gay People's Chronicle* for context, and just being a trove of knowledge and support. Also thanks to Julia Applegate, who left us a plastic bin full of magic on her front porch, which added invaluable stories to this book.

Thanks to everyone over at Arcadia Publishing for this opportunity to capture these moments in print and especially Caroline Anderson, who deftly and gently shepherded us through the process.

There were easily 30 to 40 other LGBTQ and ally heroes in Columbus who immediately responded when we cried out, "Help!" or "Is this right?!" They are board chairs, historians, nonprofit leaders, and change-makers. Though they cannot all be named, they are present in the images and words throughout the book.

And finally, to the wonderful LGBTQ community in Columbus: you may not see your face in a picture. You may not see your name in the words. But trust us—you are most definitely in this book. This is a village. And we are proud to live beside you.

Special reference must be given for the following photographers. Please support them:

Katie Forbes: www.krforbesphotography.com
Ray LaVoie: www.raylavoie.com
Emma Parker: www.emmaparkersphotography.com
Ralph Orr: tinyurl.com/RalphOrrPhotography
Andi Roberts: www.hottomatopinupacademy.com

INTRODUCTION

The same city council that voted unanimously December 14 to include unmarried partners in city workers' health-care benefits packages unanimously revoked those benefits February 8.

Four speakers at the meeting asked the council not to repeal the ordinance. Chris Cozad, a member of Citizens for Health Care, a collation of groups which had backed the measure, asked council members to be leaders by taking a stand in support of the ordinance.

"If you vote to rescind this ordinance today you send very dangerous messages," Cozad told them. "To LGBT citizens of Columbus you say, 'We can only support you if it is comfortable.' To the radical fringe in this community you say 'You can control us with your threats.' To every citizen in this city you say 'Bigotry and hatred are acceptable community values in Columbus.'"

No one was present at the meeting to speak in favor of the repeal.

—*Gay People's Chronicle*
February 12, 1999

When the Columbus City Council passed domestic partner benefits in December 1998, Columbus became the first city in Ohio to extend benefits to LGBTQ couples at a time when the national marriage equality debate was still in its nascence. For context, this was a year and a half earlier than Vermont began granting civil unions, 10 years before voters eliminated the rights of same-sex couples to marry via Proposition 8 in California, and 17 years before the US Supreme Court declared that marriage equality became the law of the land. For Columbus to take this action in 1998, it was trailblazing.

Then the opposition coalesced. At a public debate of the measure after its initial passing, Baptist minister Rev. Fred Marshall said the measure was "promoting humanity's sinful sexual sensual nature" and that "we should be as obedient to God as our dogs are to us." Linda Harvey, the president of Mission America (a central Ohio religious right organization) said that the ordinance "legitimizes homosexuality and bisexuality by force of law and gives it legitimacy it should not have." Various groups came together and vowed to place the domestic partner benefits on a voter referendum thus submitting the rights of a minority to a vote of the majority. Fearing a negative outcome, the Columbus City Council caved and repealed what they had just passed. For Columbus to take this subsequent action, it was less than trailblazing.

With this one turn of events, you have LGBTQ life in Columbus throughout the years: bold strokes that lift up the voices of those not at the table coupled with disappointing—and sometimes quite community-damaging—setbacks that mirrored what was going on both nationally and, more distinctly, in the Midwest. In speaking with so many Columbus LGBTQ individuals to put together this book, this push and pull is something they have come to expect. The prevailing sentiment in the Buckeye State capital seems to be an endless loop of inspiring advancement

followed by unsatisfying lows, which then activates more energy to create more movement forward. Rinse and repeat.

On the achievement side, the LGBTQ work that has been done in Columbus over the years is nothing less than remarkable, not just for central Ohio, nor for the Midwest, but for truly anywhere in the United States. The underground Berwick Ball that began in the late 1960s gave Central Ohioans a place to go unlike any other out there, even as the Red Party in the 1970s became a destination for LGBTQ people from around the world. The gay student group at The Ohio State University was one of the earliest documented LGBTQ student groups in the country who then sponsored the first gay rights rally ever held in central Ohio. Stonewall Union had a booth at the Ohio State Fair when LGBTQ people were simply not represented at other state fairs in our neighboring states. Events like Bat-N-Rouge, Art for Life, the Dr. Robert J. Fass AIDS Walk, Camp Sunrise, and the International Drag King Extravaganza all represent pioneering gatherings providing opportunities for the LGBTQ community to joyously gather, raise critically needed funds, and amplify issues that were being given short shrift within the wider culture at large. Columbus has never been a city sitting back waiting for something to happen; LGBTQ advancements were taking place in ways that were just not happening elsewhere.

But that is not the full story. Throughout the decades, the Columbus LGBTQ has encountered crushing obstacles, some from outside of our community and some significant ones from within. HIV/AIDS devastated the Columbus community as it did to our siblings across the country; there were countless precious lives that were snuffed out by the raging epidemic that we will never get back. Discrimination in housing, public accommodations and employment have been in evidence with alarming regularity. Bar raids once thought to be relegated to the 1960s and 1970s were still taking place in the late 1990s. Violence against the LGBTQ community—and, in particular, against LGBTQ people of color—has been ever present throughout the years and is still on the rise today. More internally, the conflict within the LGBTQ community can be as constant as it is fracturing (see: Columbus Pride 2017).

Our goal with this book was to capture as full a portrait as we could manage of LGBTQ life in Columbus over the past 50 years. We could have put together a book that solely had smiling Flaggots (a word that never gets old) throwing their brightly colored fabric in the air or members of the Columbus Women's Chorus performing their hearts out. But such a volume would not have been wholly representative of Columbus. Or we could have put together a book that solely had picket lines and protest marches or even just images of people of color being confronted by the police. But that volume would not have been wholly representative either.

The pages before you exist somewhere in the middle. We don't write about the ravage of HIV/AIDS without displaying the heroic actions of Columbus ACT UP protesters demanding change. We don't deplore our government officials ever trying to erase transgender individuals from the narrative or discount their military service without emphasizing the many times the Columbus LGBTQ community has put our trans siblings at the core of what we do. We don't document the arrests made at the 2017 Pride without featuring the solidarity that was on display in Columbus Community Pride the following year. Heck, we don't highlight Mike Pence's role in anti-LGBTQ discriminatory legislation without showing you images of the über-gay dance party that greeted his visit to Columbus in 2018.

Because all of that is LGBTQ life in the city of Columbus—bold steps forward, discouraging steps back, but always—always—a community striving for more.

One

WE CONNECT

GROUPS, ORGANIZATIONS, AND SPACES

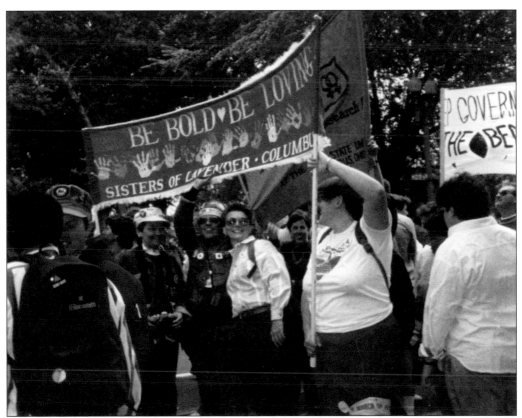

From the Flaggots to the Capitol Pride Band to Sisters of Lavender to Central Ohio Naturist Guy Alliance, there has never been a shortage of organizations providing the LBGTQ community in Columbus with an opportunity to come together around common (and sometimes very specific) interests and plan diverse activities in which they are able to channel their unique and passionate energy. (Ohio History Connection.)

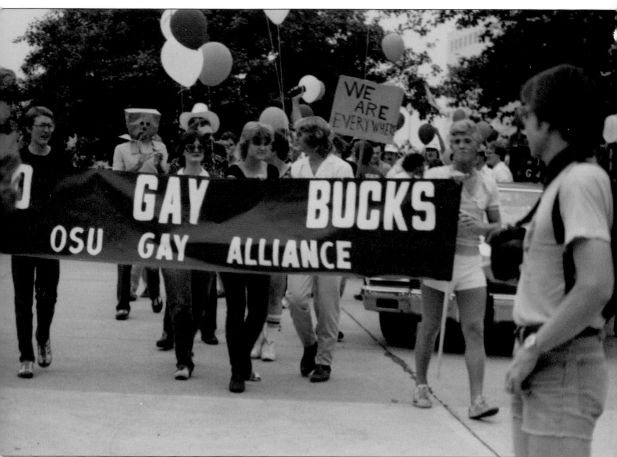

Although there are more than 15 different LGBTQ student groups currently on the roster at The Ohio State University (OSU), in the beginning, there was just one—and a legendary one at that. In 1971, the OSU Gay Liberation Front was founded but was denied official university recognition. Under a new college administration, the Gay Activists Alliance was officially approved, and they were granted office space in 1973. They created a speakers bureau in 1974, sponsored the first gay rights rally ever held in central Ohio in 1976, changed their name to Gay Alliance in 1978, and sponsored a "Gay Student Orientation" in 1980. In 1985, they changed their name to Gay and Lesbian Alliance and hosted the first Ohio State "Coming Out Day" in 1989. After a few more name changes and the introduction of several more LGBTQ groups, pride at OSU has been a constant for close to 50 years. (Ohio History Connection.)

When a Columbus chapter of Jerry Falwell's Moral Majority was established in 1981, gay and progressive activists coalesced into Stonewall Union. Their first tasks were to coordinate a statewide pride celebration and an information booth at the Ohio State Fair. By the mid-1980s, Stonewall had permanent office space, a telephone referral hotline, and was publishing the LGBTQ annual resource directory *Lavender Listings* and the *Stonewall Journal*, the longest running LGBTQ newspaper in the city at that time. Their mission at the start was focused on tolerance and acceptance, but as Stonewall Union became Stonewall Columbus, their mission evolved into increasing visibility, inclusion, and connection for the LGBTQ community. Through their programming, advocacy, and undeniable presence in the Columbus community, Stonewall Columbus is at the forefront of creating a city where our LGBTQ siblings just plain thrive. (Ohio History Connection.)

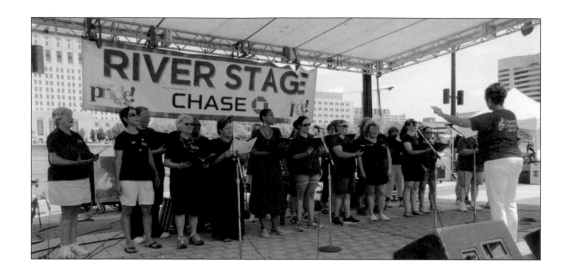

Founded in 1989 when 13 women responded to an advertisement, the Columbus Women's Chorus (CWC) first performed in March 1990 at the National Lesbian Conference Regional Caucus meeting. The feminist chorus performs music created and inspired by the lives and experiences of women from all walks of life. Their mission is firmly rooted in fostering excellence and innovation in the performance and presentation of women's music, entertaining and educating their audiences, enriching and enlightening minds and spirits, encouraging societal change, and opening hearts to diversity. With an incredible 30 year history behind them, CWC's work has been recognized with a Montreal Women's Memorial Award, numerous arts grants, and even a resolution from the Franklin County Board of Commissioners. With so many more notes to sing, the CWC has no plans in stopping the music anytime soon. (Both, Columbus Women's Chorus.)

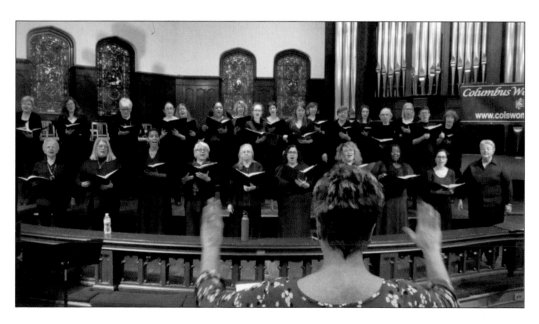

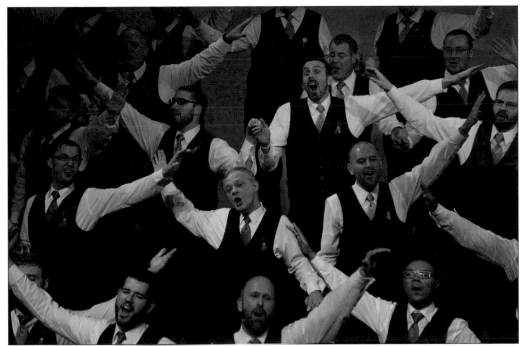

The Columbus Gay Men's Chorus first took to the stage in December 1990, with 51 men singing at the Thurber Theater on the OSU campus. Their mission 30 years later is as it was in the beginning: to foster increased recognition, understanding, and acceptance of LGBTQ individuals through music and social awareness. In addition to their full-scale concerts, the chorus also features Illuminati, a sacred music ensemble, and Vox, a premier small ensemble. From their holiday offerings to their theme concerts ("That 70s Concert," "Reel Voices," "At the Copa"), the chorus regularly entertains the masses at the Lincoln Theatre in Columbus's King-Lincoln neighborhood. (Both, Alan Jazak.)

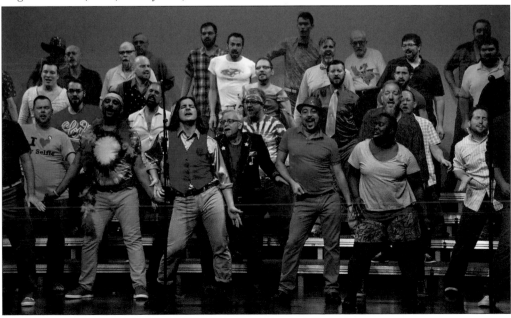

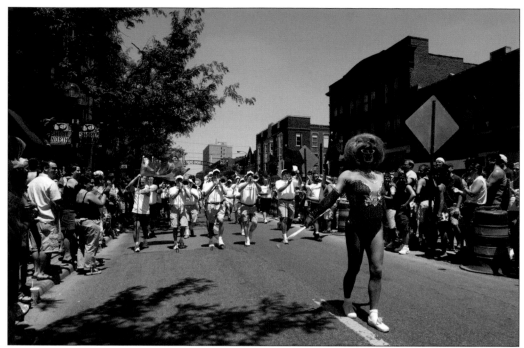

The origin story of the Capital Pride Band describes a true musical evolution: one lone trumpet player at Bat-N-Rouge in 1999 became a 13-member pep band the following year. It then swelled to 28 participants at Pride in 2003. Before the parade, the group voted on whether to play music on a flatbed truck or while marching. The latter won out, and the Capital Pride Band was born. Two decades later, they are known as the premier LGBTQ band in Ohio, boasting a roster of close to 100 musicians. With a mission of creating quality musical and social experiences for their community, they are a regular staple of concerts and pride marches both in Columbus and throughout the Midwest. (Above, Ray LaVoie; below, Alan Jazak.)

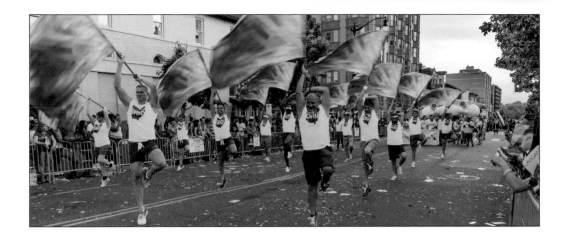

Proud, colorful, and fun, Flaggots Ohio have been using the art of color guard for decades to dazzle audiences across the country. First debuting in the 2002 Columbus Pride Parade, the goal of the Flaggots has always been to develop a volunteer visual performance ensemble that challenges members even as they entertain the crowds. From San Diego to New York City to just about everywhere in Ohio, their hundreds of performances balance uplifting ideas with a touch of playful naughtiness. As for that name, they are not shy about having taken a hate-filled word used for bullying and, instead, making it a term of endearment by adding an "L" for Love. (Both, Roger Crice.)

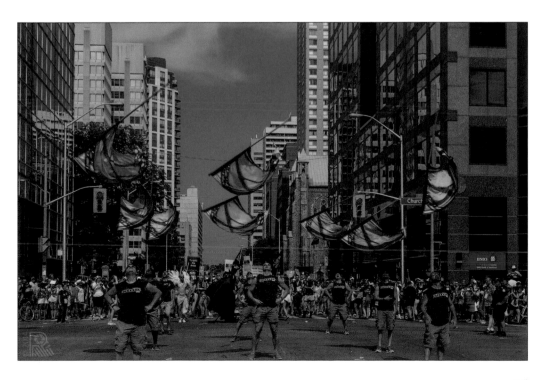

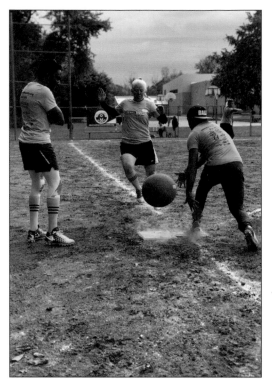

Stonewall Sports was founded in Washington, DC, in 2010 as an LGBTQ and ally community–based, nonprofit sports organization with a philanthropic aim of raising funds for local nonprofit organizations through organized sports and fundraising events. Stonewall Sports–Columbus became the 14th city expansion of the league in 2017 with a mission and vision to create a safe, inclusive and welcoming environment where individuals are comfortable playing organized and fun sports with a philanthropic heart. Stonewall Sports–Columbus launched their first league sport, kickball, in the spring of 2018. Their inaugural season had great success, and the number of registered players nearly doubled for their fall 2018 kickball season, becoming one of the largest Stonewall Sports leagues in the nation. Stonewall Sports–Columbus launched their second sport, dodgeball, in early 2019 and continues to grow as an organization looking for new opportunities to engage the community in recreation. (Left, Mark Schmitter; below, Roberto Rodriguez.)

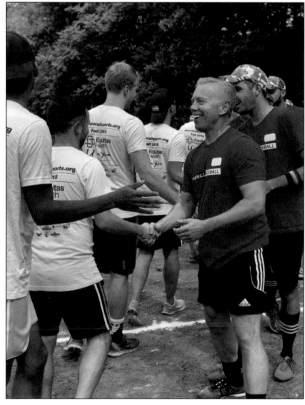

With a mission of eliminating the oppression of ageism and standing in solidarity against all oppressions, the Columbus chapter of Old Lesbians Organizing for Change (OLOC) is one of the oldest and most active in the country. In an effort to share their wisdom, preserve and enhance the lesbian voice, and increase lesbian visibility in a world that stifles and threatens to erase it, this collection of lesbians in their 60th year or older sponsors a variety of programming to create a cooperative community working for justice and well-being of lesbians young and old. (Pamela Jackson.)

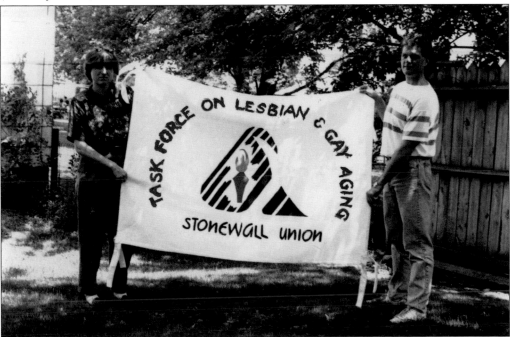

Recognizing that our LGBTQ elders and their specific needs often get short shrift in the fight for equality, Stonewall Union created the Task Force on Lesbian and Gay Aging to ensure that there was focused attention on this important population. The group provided advocacy, needs assessment, and programming, all in an effort to lift up the voices of the most experienced members of our community. (Ohio History Connection.)

17

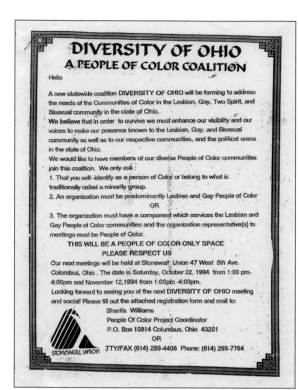

With reports coming in from all over the state that the needs of LGBTQ Ohioans of color were not being represented politically, organizationally and socially, a group came together in 1994 to ensure that their voices were being heard and amplified. Diversity of Ohio, a coalition for people of color, created a space for frank conversation about strategies and action that would enhance their visibility and make their presence known throughout the state. (Ohio History Connection.)

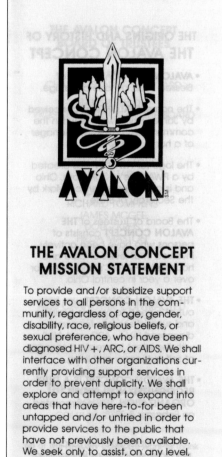

THE AVALON CONCEPT MISSION STATEMENT

To provide and/or subsidize support services to all persons in the community, regardless of age, gender, disability, race, religious beliefs, or sexual preference, who have been diagnosed HIV+, ARC, or AIDS. We shall interface with other organizations currently providing support services in order to prevent duplicity. We shall explore and attempt to expand into areas that have here-to-for been untapped and/or untried in order to provide services to the public that have not previously been available. We seek only to assist, on any level, all persons who seek our help.

Incorporated in 1988, the Avalon Concept was born out of a need to provide housing and support services for persons diagnosed with HIV/AIDS with the intent to create a scenario of self-autonomy and living. Named for the Isle of Blessed Souls, a place of refuge, the Avalon Concept raised funds and conducted extensive networking to ensure that those struck by the disease were able to access both integral care as well as a roof over their heads. (Ohio History Connection.)

Family Pride Network of Central Ohio is an organization whose purpose is to connect, educate, and support LGBTQ families. From organizing family hikes, potlucks, and kid-friendly activities to sponsoring workshops for prospective parents on adoption and foster-related issues, Family Pride Network sports a robust slate of activities aimed at providing opportunities for LGBTQ families to get together and feel the sense of community that surrounds them. (Joe Matessa.)

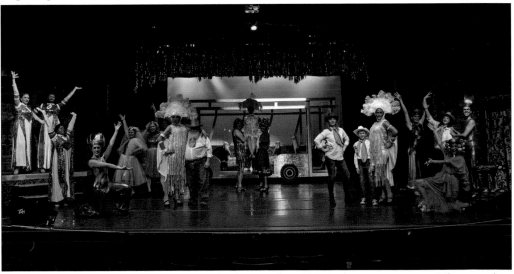

Evolution Theatre Company is Central Ohio's only LGBTQ theatre company. Their work is centered on highlighting the artistic vision of LGBTQ individuals, advancing the understanding of gender issues, and fostering the expression of creative performance arts by and about the LGBTQ community. The productions that they select to perform on stage are ones that celebrate and verify the past, present, and future of the community. (JAMS Photography.)

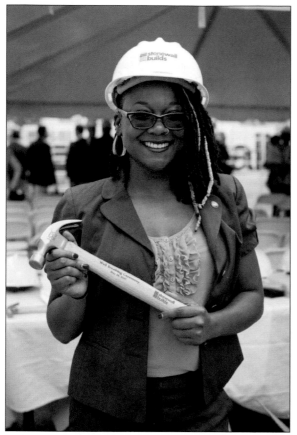

In 2015, Stonewall Columbus officially kicked off Stonewall Builds, a capital campaign to fund the renovation and expansion of their current buildings in the Short North. This $4 million campaign would specifically enable the organization to include 12,000 square feet of public space for agency programming and private events. More generally, the renovation symbolized the move to be a more effective epicenter for LGBTQ support and services and act as an important link between the LGBTQ community and Central Ohio. The successful campaign drew from donors large and small, joyously culminating with the groundbreaking on May 25, 2017, a Signing Day on September 17, 2017, and a full opening in Spring 2019. (Both, Emma Parker Photography.)

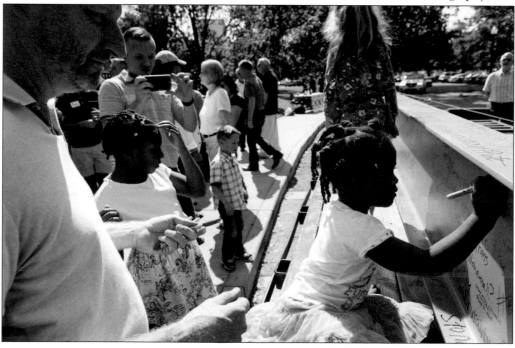

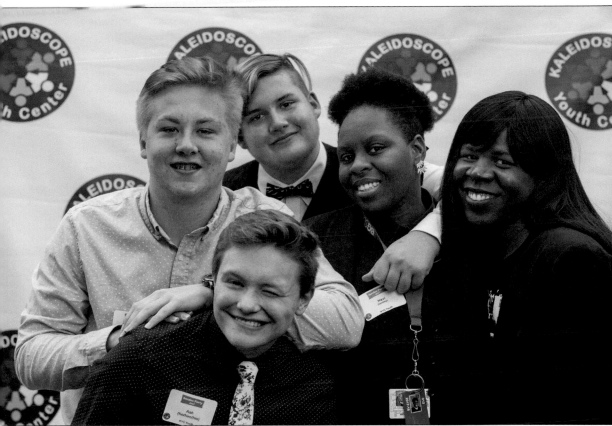

Founded in 1994, Kaleidoscope Youth Center is the only organization in Ohio solely dedicated to supporting LGBTQ youth and their allies. Originally starting out as a referral service, they quickly evolved to provide a place for youth across the spectrums of sexual orientation and gender identity to meet and socialize. Though their "home" has moved several times over the past 25 years, the commitment to creating safe and empowering spaces for youth through advocacy, education, support, and community engagement has remained steadfastly the same. They have developed programs offering self-esteem, health and wellness, and assistance with Genders and Sexualities Alliances in Columbus City Schools and Franklin County Schools. As they have done since their inception, Kaleidoscope continues to advocate for policies that help LGBTQ youth with regard to safe schools, mental health, personal development, and any other matter that would contribute to the success of our next generation of LGBTQ heroes. (Jennie Key Photography.)

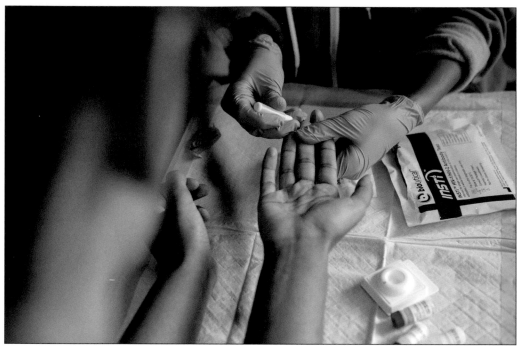

Born out of a need to create safer spaces for transgender, gender nonconforming, and nonbinary youth and young adults of color throughout Columbus, Mozaic exists as both a community space as well as a wellness program. Their mission is to have no new diagnoses of HIV among the population they serve by providing testing, safer sex supplies, and, most importantly, an all-genders-welcome community of support. (Emma Parker Photography.)

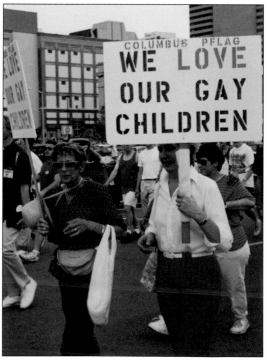

The idea for PFLAG began in 1972 when Jeanne Manford marched with her son Morty in New York's Christopher Street Liberation Day March, the precursor to today's Pride parade. After many gay and lesbian people ran up to Jeanne during the parade and begged her to talk to their parents, she decided to begin a support group. The Columbus chapter of PFLAG continues that storied tradition, meeting twice a month, marching in Pride, and being a visible presence in the city to promote the health and well-being of lesbian, gay, bisexual, and transgender persons, their families, and their friends. (Ohio History Connection.)

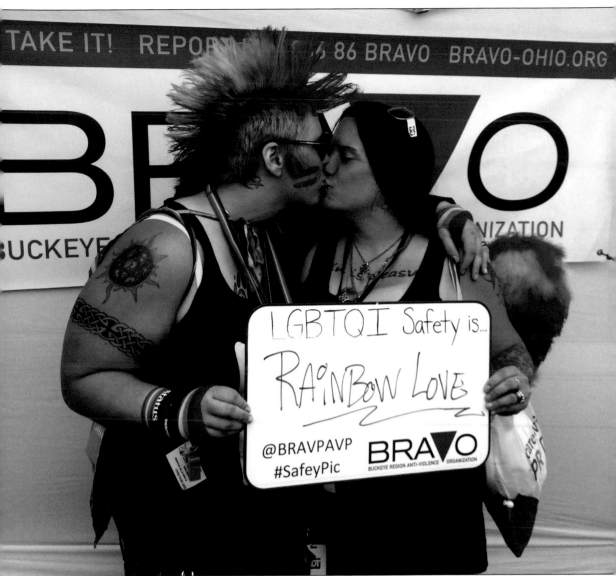

Though there have been so many significant and public milestones for the LGBTQ community, the reality is that there continues to be an increase in homicides of LGBTQ people, with LGBTQ people of color and transgender and gender nonconforming people making up the majority of those homicides. Additionally, LGBTQ and HIV-affected people of color comprise the majority of the total numbers of survivors who report intimate partner violence. As a founding member of the National Coalition of Anti-Violence Programs, the Buckeye Region Anti-Violence Organization (BRAVO) was created in 1996 to provide comprehensive individual and community programs for advocacy and support to LGBTQ survivors of hate and bias violence, discrimination, intimate partner violence, stalking, and/or sexual assault. From their helpline to their community-wide education to their legal, medical and law enforcement advocacy/accompaniment, BRAVO is constantly working towards a future without violence. (BRAVO.)

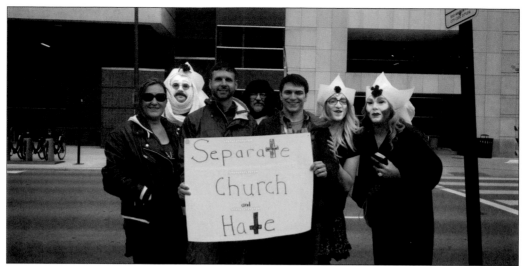

The Abbey of the Cardinal Sins first manifested in 2014 as Columbus's order of the legendary Sisters of Perpetual Indulgence. Originally formed in San Francisco in the late 1970s, the Sisters quickly became known for their creative activism and ability to raise much-needed funds in some truly dire times. They organized the first AIDS Candlelight Vigil in 1983 and, over the years, have inspired the installation of more than 50 Houses around the world practicing their "ministry of presence." With their roots firmly planted in this "sistory," the Columbus chapter serves the community by hosting events like the "Columbus Bitch Trials"—a roast of a local drag queen—and the "Project Nunway" fashion show to raise money for charities such as Project Open Hand and the OSU Star House. They also pass out condoms and educate the public on the Pre-Exposure Prophylaxis (PrEP) HIV-prevention pill. (Both, The Archives of the Abbey of the Cardinal Sins; below, photograph by Dozor Photography.)

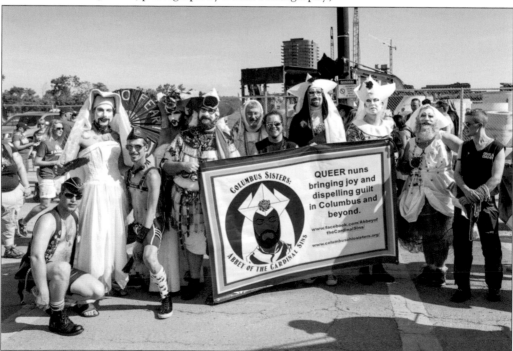

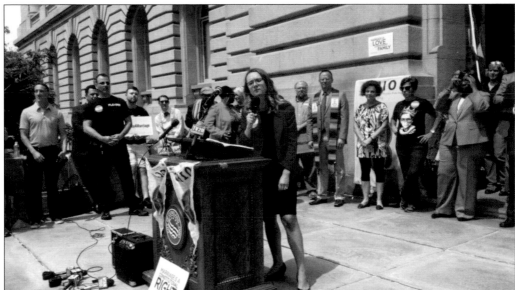

Equality Ohio was founded in 2005 by a group of 65 dedicated LGBTQ activists and allies from all corners of Ohio after voters passed a constitutional amendment prohibiting same-sex marriage and civil unions. Over a decade later, Equality Ohio's work is broad and focuses on multiple aspects of LGBTQ equality in Ohio, engaging in policy work, advocating for LGBTQ Ohioans at every level of government (including supporting the creation of local protection ordinances in 21 cities and one county), and creating opportunities to disseminate information about the laws and policies that affect our lives. From fighting for marriage equality, to addressing the lack of housing, public accommodations, and employment protections in Ohio, to fighting back the out-of-nowhere discriminatory legislation that sporadically pops up (see 2018's Pastor Protection Act), Equality Ohio stands both proudly on the front lines as well as strategically in the political backrooms, all in the fight for equality in the Buckeye State. (Both, Grant Stancliff.)

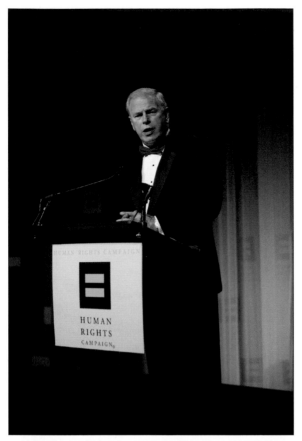

Though the national headquarters for the Human Rights Campaign (HRC) is housed 400 miles east in Washington, DC, the Columbus chapter of HRC acts as a central hub for LGBTQ Ohioans looking to make a difference. HRC was founded by Steve Endean in 1980 as one of the first gay and lesbian political action committees in the United States. The organization now boasts more than 3 million members worldwide and is one of the largest civil rights organizations working towards equality. The Columbus chapter dons their black ties and cocktail dresses every summer for their annual gala which has raised much-needed money to help advance LGBTQ equality. Other events throughout the year have included Bowling Equality Forward and various film screenings raising awareness and funds. (Both, Ray LaVoie.)

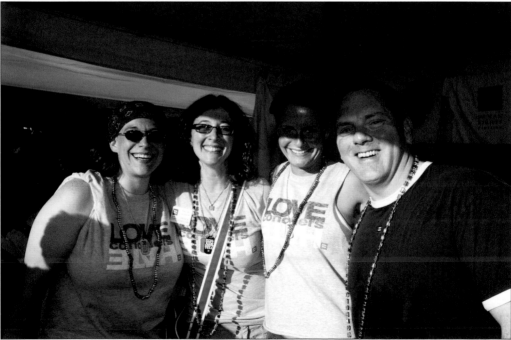

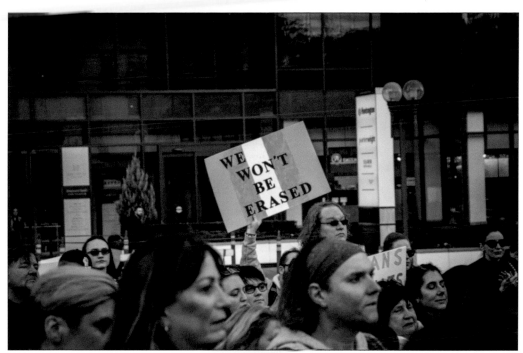

What started out as a small gathering of friends turned into a quarterly newsletter and ultimately resulted in TransOhio, a statewide organization that serves the Ohio transgender and ally communities. Since 2005, TransOhio has been providing services, education, support, and advocacy, which promotes and improves the health, safety, and life experience of the Ohio transgender individual and community. This completely volunteer-run organization serves as a vital bridge to other LGBTQ and ally communities: consulting, connecting, and advising on a variety of Ohio initiatives and legislation. They are perhaps best known for the TransOhio Transgender and Ally Symposium, an annual event that started in 2008 as a one-day event and has since grown into a three-day conference with 75-plus workshops. (Above, Staley Joseph; right, Lisa McLymont.)

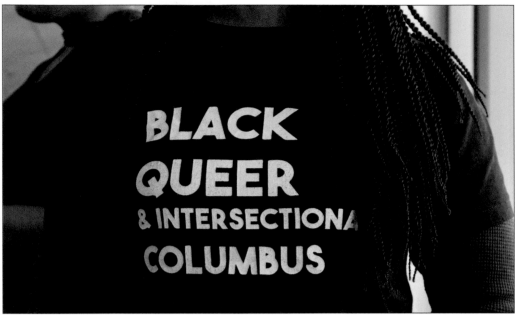

Black Queer and Intersectional Collective (BQIC) is a grassroots community organization in Central Ohio that works towards the liberation of black queer, trans, and intersex people from all walks of life through direct action, community organizing, education on their issues, and creating spaces to uplift their voices. BQIC believes that moving towards a world where black LGBTQIA+ people can thrive must contain social and economic equity, access to food, access to free and affirming health care, and the abolition of harmful systems of oppression. To achieve these goals, BQIC has been engaged in a number of initiatives including organizing Columbus Community Pride 2018, working on the grassroots defense campaign to #FreeTheBlackPride4, and sponsoring a diverse set of events from open mics to Free Resource Fridays to teach-ins. The T-shirt pictured above shows the original name of the organization. (Above, Katie Forbes; below, Ariana Steele.)

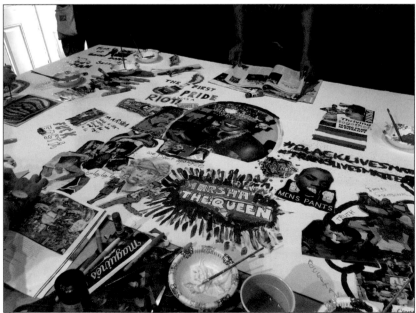

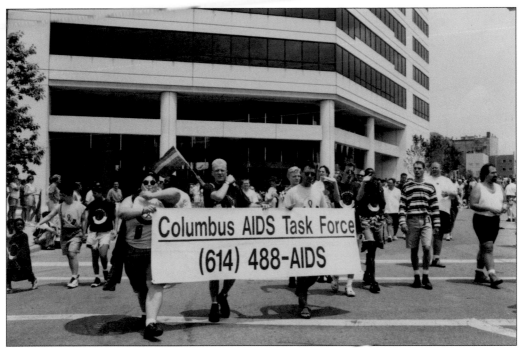

The agency now known as Equitas Health draws from a rich history of past efforts in Columbus to provide diverse healthcare and social services, especially for LGBTQ and HIV/AIDS-affected communities. The origin story begins in 1984 with the establishment of AIDS Resource Center Ohio (ARC Ohio), an organization delivering social service support during the early stages of the epidemic. In 2011, ARC Ohio merged with the Columbus AIDS Task Force (keeping their name) to provide even more comprehensive services, including healthcare the following year through their Short North and Dayton Medical Centers. Both sites exceeded their goals for patient enrollment. They also transitioned in services from solely focusing on HIV/AIDS to providing population health for the entire LGBTQ community. In 2016, ARC Ohio rebranded as Equitas Health, growing into one of the largest community-based health care systems of its kind, serving more than 67,000 patients in Ohio, West Virginia, and Kentucky in 2018 alone. (Above, Ohio History Connection; below, Lisa McLymont for Equitas Health.)

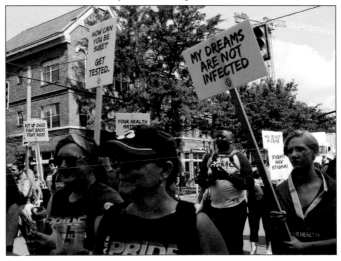

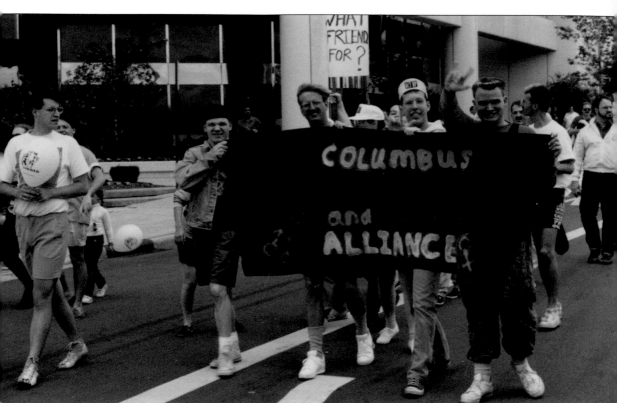

Columbus has been the home to various organizations for deaf LGBTQ individuals over the years. In the late 1970s, there were various members affiliated with the Buckeye Rainbow Society of the Deaf. In the 1980s and 1990s, there was the Columbus Deaf and Gay Lesbian Alliance, and then the Buckeye Rainbow Alliance of the Deaf founded in 2000 (an official chapter of the national Rainbow Alliance of the Deaf). The narrative thread connecting all of these groups has always been establishing and maintaining a supportive community of deaf LGBTQ individuals as they provide a place for connection and discussion of practical problems and solutions related to their experiences being deaf in the greater Columbus community. They made their presence known carrying a banner at Pride, waving to the crowds on a float, and via various social and advocacy events throughout the years. (Ohio History Connection.)

Camp Sunrise, founded in 1994, was Ohio's only summer camp program developed specifically for children impacted by HIV/AIDS. Each summer, as many as 100 children experienced the joys of friendship, the love, and support of a caring community, and an encouraging environment free of the stigma surrounding HIV/AIDS. The experience had everything you would expect from camp: arts & crafts, sports, music, swimming, high ropes, movie nights, talent shows, and more. But the backdrop of that supportive community where everyone was able to be their authentic self truly distinguished the experience. The good news: with the nearly eradicated mother-to-child transmission of HIV, there was a steady decline in the number of campers. The bad news: due to this decline, 2018 was the last year of Camp Sunrise. (Both, Ray LaVoie.)

Reading really is fundamental, and one can learn their ABCs just by studying a list of all of the gay bars that have come and gone in Columbus over the years. Awol, Bananas, Blondies, Cabana Club, Cleopatra's Lounge, Downtown Connection, Eagle Tavern, Far Side—and that is just the first six letters. Columbus queer nightlife has ranged from underground dives to upscale chic to standing room only on the balcony looking down at the performing drag entertainment. And lest one thinks that the literacy bar crawl would leave them stranded for the coveted 10-point Scrabble letters, fear not—Q Bar and U Be U Bar are covered in the reading "QU"est. (Both, Ray LaVoie.)

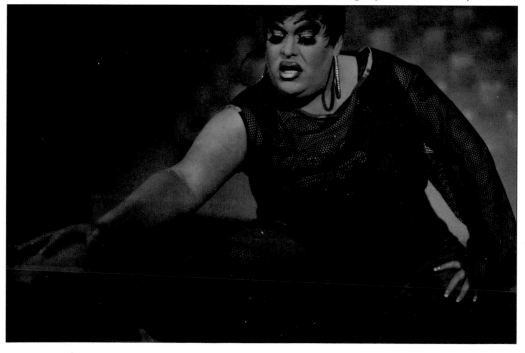

Two

WE GATHER
EVENTS

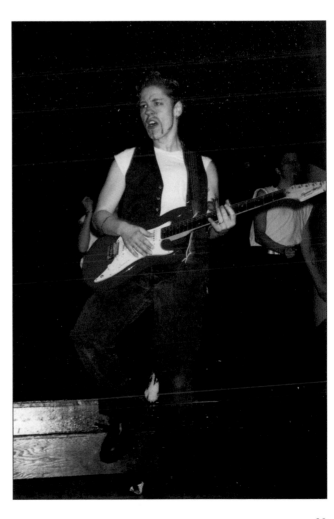

The Columbus LGBTQ community has physically come together in a broad range of ways. Whether it is a raucous crowd appreciating the talents of a drag show, a healing weekend for those affected with HIV/AIDS, or a committed group of citizens simply walking together to raise much-needed funds, these events provided a vivid illustration of the sheer power of strength in numbers. (Julia Applegate.)

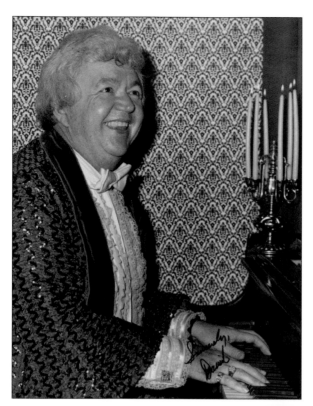

David Zimmer is no less than a beloved local legend. For more than 40 years, the gifted pianist entertained audiences all over Columbus (and quite a bit beyond) as Dolly Divine, whom he preferred to call a performer rather than drag queen—and perform he did. Inspired by Liberace, every appearance was the utmost in eye-catching: costumes with ruffles and flowing fabric, glittering sequined shoes, and bejeweled accessories that caught the light every which way Dolly turned. From dazzling his fellow enlistees in the army with impromptu numbers as a young man to charming all the guests at the Diamond Jubilee thrown for him by the German Village Meeting Haus for his 75th birthday in 2004, David took his role as entertainer quite seriously. David passed away a few months after the Jubilee after a long life spent bringing smiles to the faces of everyone around him. (Both, Ohio History Connection.)

One of David Zimmer's biggest contributions to the LGBTQ community in Columbus was the creation of the Berwick Ball. In 1964, Zimmer helped to organize an invitation-only costume ball in Columbus; revelers only found out where the party was being held by calling a telephone number the day of the event. The secrecy was a direct result of Columbus's anti-sodomy and cross-dressing laws, written in the 1800s but still on the books in the 1960s. First held at the American Legion Hall, the event was hugely popular with the LGBTQ community, with patrons arriving in drag and formal attire. The legendary party became an annual hot-ticket soirée and featured performances by artists like Dolly Divine as well as awards for costumes and volunteerism. The final Berwick Ball was held in 2000. (Both, Ohio History Connection.)

55

Sec. 10. That if any person or persons shall keep a house of prostitution, or permit or suffer prostitution in or about any house, he or she may at the time occupy or exercise control over, within this city, or shall be guilty of prostitution themselves, or shall harbor or board any common prostitute or prostitutes, he, she or they, so offending, on conviction, shall be fined any sum not exceeding fifty dollars, or be imprisoned any length of time not exceeding fifteen days, or both, at the discretion of the mayor. *Houses of prostitution prohibited.*

Sec. 11. That if any person shall keep a disorderly house, or permit any disorderly conduct, in or about his, her or their house, to the annoyance of the neighborhood, every person so offending, shall, on conviction thereof, be fined any sum not exceeding twenty dollars, or be imprisoned any time not exceeding ten days, or both, at the discretion of the mayor. *Disorderly houses prohibited.*

Sec. 12. That if any male be found dressed in female apparel, or any female dressed in male apparel, any where in this city, every person so offending, shall be fined, on conviction thereof, in any sum not exceeding five dollars, or imprisoned any time not exceeding five days, or both, at the discretion of the mayor. *Male dressing in female, or female dressing in male's apparel prohibited.*

Sec. 13. That all ordinances to suppress immoral practices heretofore passed, be and the same are hereby repealed. *Former ordinances repealed.*

R. W. McCOY, *President.*

J. Ridgway, Jr., *Recorder.*
Feb. 14, 1848.

AN ORDINANCE

To regulate the size of Brick and define the measure of Lime and other articles in the city of Columbus.

Sec. 1. Be it ordained and enacted by the City Council of Columbus, That brick for building, hereafter made for sale, to be used in this city, shall be made in moulds measuring nine inches long, four and three-eighths inches wide, and two and a half inches thick: Provided, however, That special contracts may be made for brick of a different size, and of various shapes, such as may be required for specific purposes. *Size of brick defined.*

Sec. 2. That the measure of lime, coal and all articles, usually sold by heaped measure, shall be five pecks or 26 88 cubic inches to the bushel, and the standard for even measure shall conform to the standard established by the State of Ohio. *Measure of lime, coal &c. defined.*

Sec. 3. That each wagon-bed for delivering lime or sand, shall have its sides and ends of equal height, and the width of bed uniform, shall be ganged by the city surveyor and marked on the inside so as to designate the quantity contained, from 20 bushels upwards, by marks varying ten bushels each, the meas- *Wagon beds for delivering of lime or sand to be ganged.*

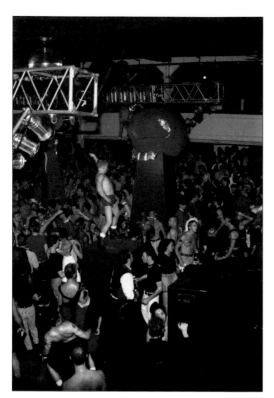

In 1975, artist and designer Corbett Reynolds purchased the Avondale Theater on West Broad Street and turned the Art Deco theatre into a gay-centric nightclub called Rudely Elevant. Inspired by the discos in New York and Chicago, the space was notorious for its theme parties and guest performers like Grace Jones and Divine. Reynolds gained national attention for his creation of the Red Party, a circuit party patterned after his favorite color. Running from 1977 to 2001, the Red Party drew thousands of circuit-goers from around the world to an event that was part performance art, part art installation, and more dancing than could possibly be measured. They also featured such diverse guest hosts as Holly Woodlawn and Tammy Faye Baker Messner. Reynolds died of a heart attack just months before the 25th anniversary of the Red Party ("Rome" was the theme that year), an event that the executors of his estate decided to retire. (Both, Corbett Reynolds Papers, Archives Center, National Museum of American History, Smithsonian Institution.)

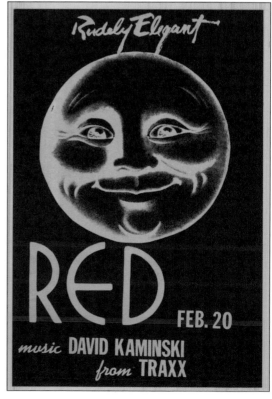

The Stonewall Columbus Annual Awards Gala has taken many forms over the years, from more of a business casual sit down dinner to an "All That Jazz"–themed affair with flapper dresses and jazz orchestras. Yet no matter what the evening offered with regard to entertainment, every year offered the opportunity for the LGBTQ community to come together to recognize individuals and organizations who made extraordinary contributions to the Columbus community and to highlight the latest information and strategies with regard to the ongoing fight for equality. In both the early years and more recent times, the event brought together LGBTQ individuals from all corners of Columbus to be in the same room to celebrate and commune together as one. (Both, Ohio History Connection.)

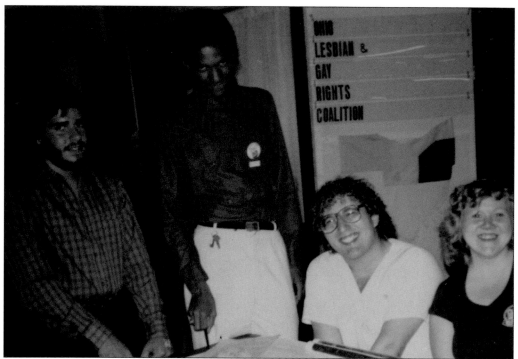

There are few better opportunities to educate the public in the Buckeye State than having a presence at the annual Ohio State Fair. With hundreds of thousands of patrons passing through the fairgrounds each year, the fair presents a unique opportunity to interact with members of the public who are highly unlikely to show up for a Pride event. Since the late 1970s, LGBTQ groups have been granted booth space to distribute pamphlets on topics including legal recognition, HIV/AIDS information, and diversity within the LGBTQ community. Stonewall Columbus has been a constant presence at the Fair, proving year after year the critical importance of meeting the people where they are. (Both, Ohio History Connection.)

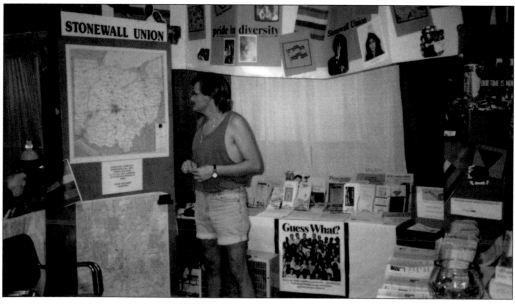

But not all were happy about the presence of LGBTQ material at the Ohio State Fair. In 1992, fair organizers decided not to send an invitation to Stonewall Union despite their having been present at the event for the previous 14 years. The fair's general manager had apparently decided that their material was not "decent" enough for the attendees and cited various complaints he had received about the homosexual material. The Ohio Expositions Commission had to get involved, ultimately deciding that there were no grounds to deny Stonewall Union the booth. Both the assistant state attorney general as well as the ACLU agreed with commission's decision, readmitting Stonewall back into the mix of tables and pamphlets. (Both, Ohio History Connection.)

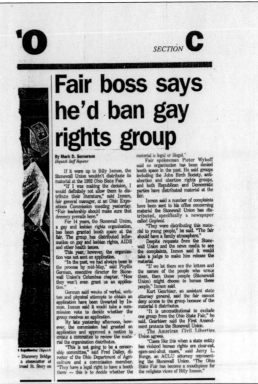

Fair boss says he'd ban gay rights group

By Mark D. Somerson
Dispatch Staff Reporter

If it were up to Billy Inmon, the Stonewall Union wouldn't distribute its material at the 1992 Ohio State Fair.

"If I was making the decision, I would definitely not allow them to distribute their literature," said Inmon, fair general manager, at an Ohio Expositions Commission meeting yesterday. "Fair leadership should make sure that decency prevails here."

For 14 years, the Stonewall Union, a gay and lesbian rights organization, has been granted booth space at the fair. The group has distributed information on gay and lesbian rights, AIDS and other health issues.

This year, however, the organization was not sent an application.

"In the past, we had always been in the process by mid-May," said Phyllis Gorman, executive director for Stonewall Union's Columbus chapter. "Now they won't even grant us an application."

Gorman said weeks of verbal, written and physical attempts to obtain an application have been thwarted by Inmon. Inmon said it would take a commission vote to decide whether the group receives an application.

By late yesterday afternoon, however, the commission had granted an application and approved a motion to create a committee to review the material the organization distributes.

"This is not going to be a censorship committee," said Fred Dailey, director of the Ohio Department of Agriculture and a commission member. "They have a legal right to have a booth there — this is to decide whether the material is legal or illegal."

Fair spokesman Pieter Wykoff said no organization has been denied booth space in the past. He said groups including the John Birch Society, anti-abortion and abortion rights groups, and both Republican and Democratic parties have distributed material at the fair.

Inmon said a number of complaints have been sent to his office concerning material the Stonewall Union has distributed, specifically a newspaper called *Gaybeat.*

"They were distributing this material to young people," he said. "The fair should have a family atmosphere."

Despite requests from the Stonewall Union and the news media to see the complaints, Inmon said it would take a judge to make him release the material.

"If we let them see the letters and the names of the people who wrote them, then these people (Stonewall Union) might choose to harass these people," Inmon said.

Kurt Gearhiser, an assistant state attorney general, said the fair cannot deny access to the group because of the material it distributes.

"It is unconstitutional to exclude one group from the Ohio State Fair," he said. Gearhiser said the First Amendment protects the Stonewall Union.

The American Civil Liberties Union agrees.

"Cases like this when a state entity has violated human rights are clear-cut, open-and-shut cases," said Jerry L. Bunge, an ACLU attorney representing the Stonewall Union. "The Ohio State Fair has become a mouthpiece for the religious views of Billy Inmon."

Discovery Bridge a stonecutter at Broad St. Story on

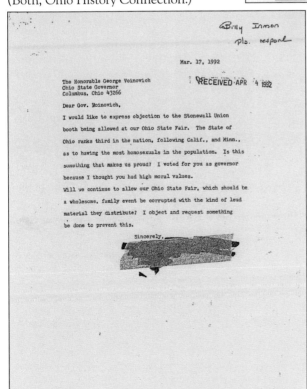

Billy Inmon
pls. respond

Mar. 17, 1992

The Honorable George Voinovich RECEIVED APR 4 1992
Ohio State Governor
Columbus, Ohio 43266

Dear Gov. Voinovich,

I would like to express objection to the Stonewall Union booth being allowed at our Ohio State Fair. The State of Ohio ranks third in the nation, following Calif., and Minn., as to having the most homosexuals in the population. Is this something that makes us proud? I voted for you as governor because I thought you had high moral values.

Will we continue to allow our Ohio State Fair, which should be a wholesome, family event be corrupted with the kind of leud material they distribute? I object and request something be done to prevent this.

Sincerely,

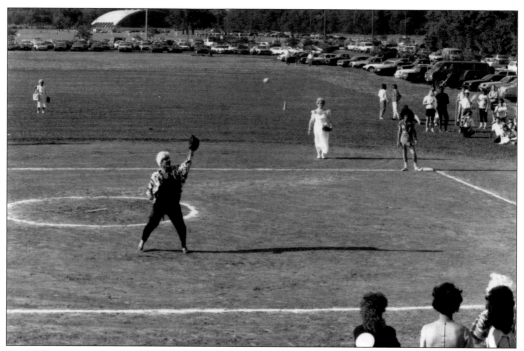

Bat-N-Rouge is an annual highlight in Columbus with spectators flocking to see all the frocking and frolicking that serves as the closing event for Columbus Pride. Now one of the oldest charity events in the city, the drag softball game first went up to bat sponsored by Stonewall Union. The event has since been operated by the Columbus Lesbian and Gay Softball Association. Over the years, Bat-N-Rouge has raised hundreds of thousands of dollars for state and local charities ranging from The Ohio AIDS Collation to Camp Sunrise to Pater-Noster House to many more—a true home run, indeed. (Both, Ohio History Connection.)

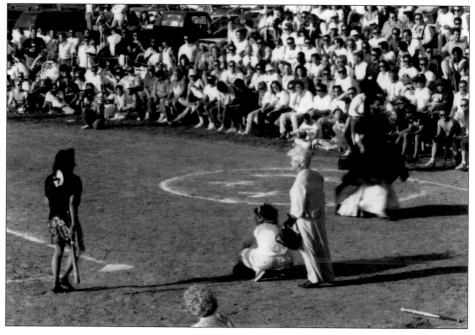

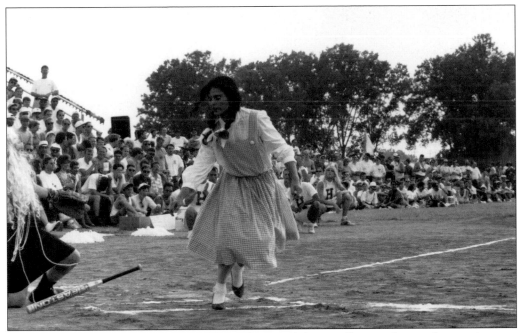

With Bat-N-Rouge, each year brings a different line-up of players, officials, fans, and entertainment. Thus, to capture the overall feel of the event is near impossible. Take this example of the *Gay People's Chronicle*'s coverage of the 15th-anniversary event in 2002: "In the seven-inning contest, the New Girls defeated the Hygienes by a score of 17 to 3. Emceed by comedienne Maggie Cassella, the game was marked by high camp and saucy behavior. Why the New Girls had such an edge is an interesting question. Hedwig was certainly a power hitter; perhaps the answer lies in the New Girls' inclusion of 'Stone Cold Steve Austin,' a drag king replete with handlebar mustache. Spectators found it heartening to see drag queens and drag kings standing together for such a good cause." (Above, Brian DeWitt; below, Ray LaVoie.)

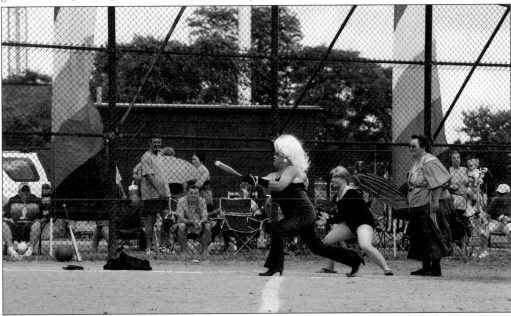

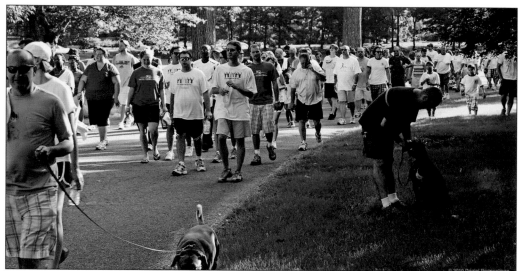

Since 1989, over 30,000 people have participated in the Dr. Robert J. Fass AIDS Walk Central Ohio, one of only a handful of AIDS walks left in the country. For two decades, the Columbus-based AIDS Walk Ohio has raised millions of dollars and an immeasurable amount of awareness for HIV/AIDS service organizations through educational and promotional activities leading up to the walk and through the participation of walkers, runners, civic leaders, corporations, and community members all coming together for the annual event. The name of the event honors the legacy of the late Dr. Robert J. Fass, an internationally respected scientist and teacher whose work spanned the field of infectious diseases from laboratory assessment of new antibiotic to clinical trials of anti-invectives. Dr. Fass was the principal investigator of The Ohio State University AIDS Clinical Trials Unit since its inception in 1989 and trained hundreds of residents and students to work in the field of infectious diseases. (Above, Daniel Poeppleman; below, Ray LaVoie.)

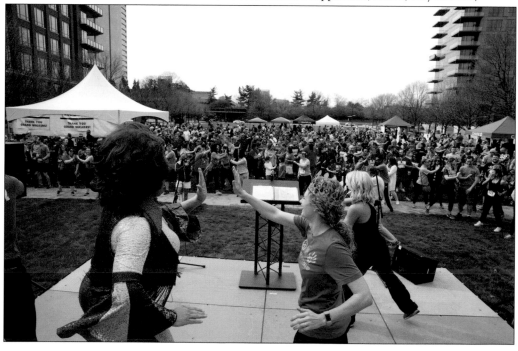

Art for Life is a biennial art auction, created in 1989, that has helped raise awareness and millions of dollars in funding for HIV/AIDS medical care, prevention education, testing, and advocacy services. A true highlight on the Columbus calendar, the event is not only a fête honoring the arts community and Equitas Health's life-saving work, but also a celebration of life and the artists who enrich it. With live and silent auctions which feature some of the best local and internationally recognized artists coupled with live entertainment for the thousands of attendees, Art for Life is well regarded as the most successful charity art auction fundraiser in Ohio. (Both, Ray LaVoie.)

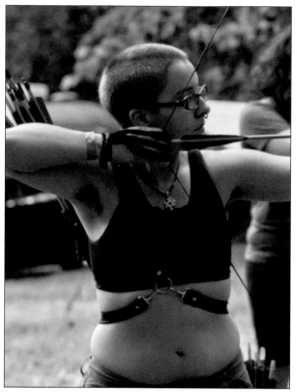

Workshops, arm-wrestling competitions, archery, camaraderie, and music—put them all together and you have the legendary Ohio Lesbian Festival (OLF). As opposed to the Michigan Womyn's Music Festival, which met in a remote part of that state, OLF was created in 1986 to be a more accessible opportunity for women to gather in the Buckeye State. Over the years, OLF has been held in many different spaces, from the Frontier Ranch in Pataskala to the Legend Valley in Thornville to Hoover YMCA Park in Lockbourne. Attendance has quadrupled in size with 1,500 women attending the festival in recent years from all over the country, necessitating the addition of two days onto the schedule. Unlike their exclusionary (and now defunct) neighbor festival to the northwest, OLF allows all women to attend, be they lesbian, bisexual, straight, cisgender, or transgender. OLF's motto is "All Womyn Welcome. Always." (Both, Andi Roberts.)

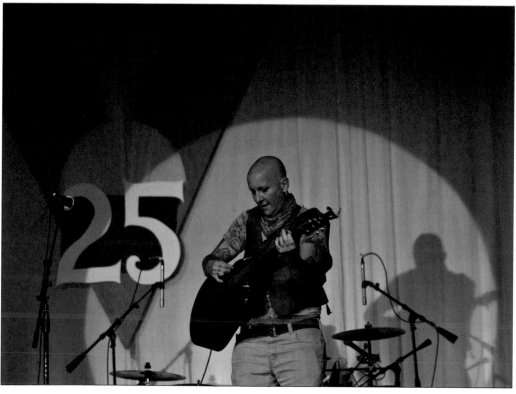

Music has always been central to the Ohio Lesbian Festival (OLF) experience. With relatively few women's festivals left in the country, musical artists and avid listeners flock to OLF to partake in the unique experience that only such a structured demographic can provide. Before her appearance at the 2018 festival, iconic singer/songwriter Cris Williamson spoke to the Columbus Dispatch. Williamson, who was part of the formation of the famed lesbian record label Olivia in the mid-1970s, reflected on the importance of women-only festivals like OLF. "The presence of powerful women all in one room is unbelievable," she said. "Women are always in rooms full of men, but it's never been the other way. They're sort of terrified, but we don't care. It's like, 'Get a set.'" (Both, Andi Roberts.)

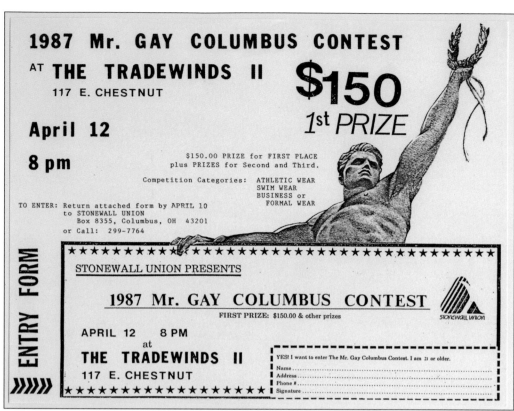

1987 Mr. GAY COLUMBUS CONTEST
AT THE TRADEWINDS II
117 E. CHESTNUT

$150
1st PRIZE

April 12

8 pm

$150.00 PRIZE for FIRST PLACE
plus PRIZES for Second and Third.

Competition Categories: ATHLETIC WEAR
SWIM WEAR
BUSINESS or
FORMAL WEAR

TO ENTER: Return attached form by APRIL 10
to STONEWALL UNION
Box 8355, Columbus, OH 43201
or Call: 299-7764

ENTRY FORM

STONEWALL UNION PRESENTS

1987 Mr. GAY COLUMBUS CONTEST
FIRST PRIZE: $150.00 & other prizes

Stonewall Union

APRIL 12 8 PM
at
THE TRADEWINDS II
117 E. CHESTNUT

YES! I want to enter The Mr. Gay Columbus Contest. I am 21 or older.
Name ...
Address ...
Phone # ...
Signature ...

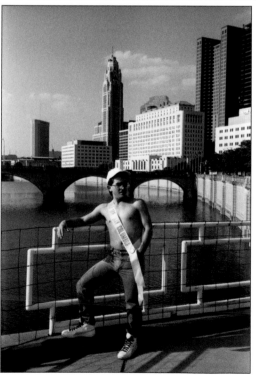

And the category is athletic wear! Swimwear! Business or formal wear! Solutions to world peace! Okay, maybe not that last one. Still, the competition for Mr. Gay Columbus was fierce, and these gents were in it to win it. Sponsored by Stonewall Union, the contest carried with it a $150 cash prize for the winner, which paled in comparison to the bragging rights. So long as one was 21 years old and mailed in the entry form 48 hours before the contest was to begin, they had a fighting chance to take home the sash. Pictured here is Danny Spears, the titleholder for 1987 Mr. Gay Columbus, posing for some candid shots by the river downtown. (Both, Ohio History Connection.)

On September 7, 2013, AIDS Resource Center Ohio held RED Columbus, a fundraiser at the Port Columbus International Airport Landmark Aviation Hangar. Attendees were treated to the spectacle of dining at tables decorated by some of Columbus's top artists and designers around the central theme of "Wanderlust." The event was held again in 2015 (theme: the Golden Age of Hollywood), and together, the two events raised hundreds of thousands of dollars to assist in providing meals, housing, healthcare, testing and prevention, stigma reduction, counseling, and most of all, compassion and hope to those living with HIV and AIDS in Ohio. The name of the event gave a nod to the contributions of Corbett Reynolds and his Red Party. (Both, Emma Parker Photography.)

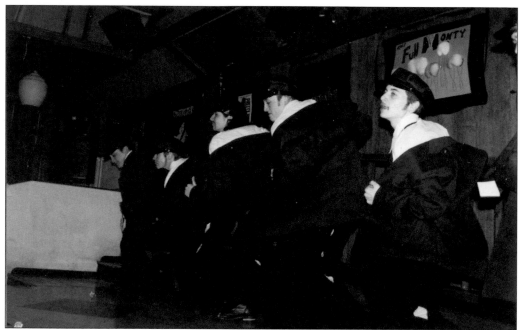

The first International Drag King Extravaganza (IDKE) took place on October 15–17, 1999. It was a first-of-its-kind event: a collaborative, noncompetitive gathering of drag kings, their fans, and the people who studied, photographed, and filmed them. The event was dedicated to both the celebration of the mutability and performance of gender as well as a sense of collaboration rather than competition or hierarchy. In 2001, a "Bio Queen Manifesto" was presented to request that IDKE become more inclusive of all gendered performance. In 2004, the proposal was approved, resulting in the name change to International Drag King Community Extravaganza, thus creating a more all-encompassing gender arena where all forms of gender expression were welcomed and nurtured. (Both, Julie Applegate.)

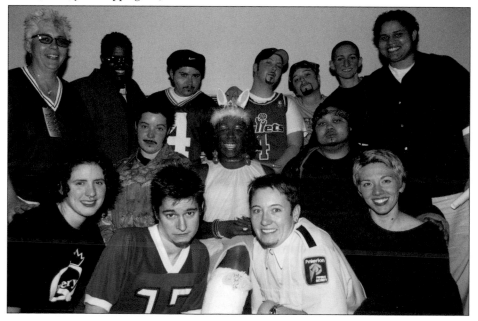

In its fifth year, IDKE realized their true potential as a traveling annual conference and held their first non-Columbus event in Minneapolis from October 17–19, 2003. Two years later, they went international, traveling to Winnipeg, Canada, from October 20–24, 2005, where they were hosted by the Gender Play Cabaret. So much more than a one-shot performance, each IDKE featured a full array of events: Dragdom (a space for all people to perform in drag with or without rehearsal), Showcase (rehearsed performers and the largest attended event), Conference (keynote speakers and workshops), Brunch (often featuring performances), and Art Exhibit/Film Festival (showcasing drag content). In 2008, Frameline Studio produced *A Drag King Extravaganza*, a documentary short detailing the complex world of drag kings and their journey of performing at IDKE. (Both, Julia Applegate.)

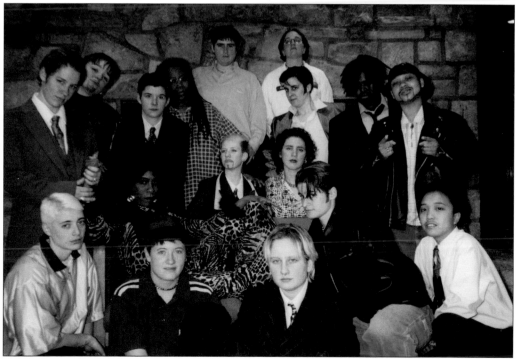

The

Ohio AIDS Coalition

presents the

Eighth, All-Ohio

HEALING WEEKEND

FOR PEOPLE LIVING WITH

HIV INFECTION, ARC

AND AIDS

MAY 25-27, 1990

CEDAR HILLS CONFERENCE CENTER

PAINESVILLE, OHIO

As HIV/AIDS devastated the LGBTQ community in the late 1980s, the Ohio AIDS Coalition began offering Healing Weekends four times a year. The goal of the three days was to introduce the 60 participants to a number of healing modalities that could be used to complement the traditional medical care and provide them with a community of caring that could bring an end to isolation and fill them with hope. (Ohio History Connection.)

An always-dazzling fixture in the Columbus nightlife scene, Mary Ann Brandt has been bringing her Christmas show to the December crowds for decades. With a ton of special guests, her own song stylings, and her distinctive brand of entertaining comedy, there is no better way to ring in the holidays and spread that Christmas cheer. (Ray LaVoie.)

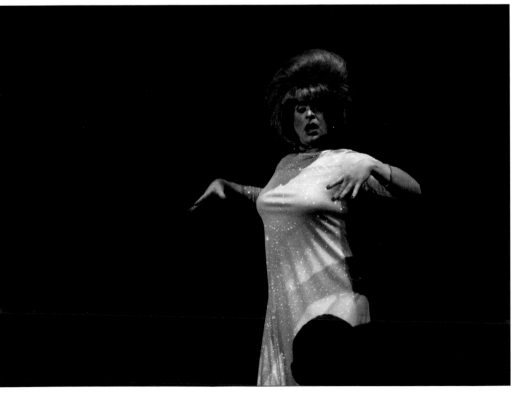

Already an annual highlight for a number of years, "Night of 100 Drag Queens" made history on July 26, 2014, at Axis Nightclub. Although the night did not quite live up to its billing, the 55 drag queens and kings who took to the stage for the final number ("It's Raining Men") were more than enough to break the Guinness World Record for the Largest Drag Queen Stage Show. The event was a fundraiser for the 2015 Gay Softball World Series, raising more than $13,000 for the cause. Although the record has since been broken by 73 drag queens on the stage at Pride Toronto 2016, co-host Nina West marveled at the Columbus effort: "I reached out to many performers and then friends and community members just started jumping in as well because they wanted to be part of it—they wanted to be a part of history." (Both, Ray LaVoie.)

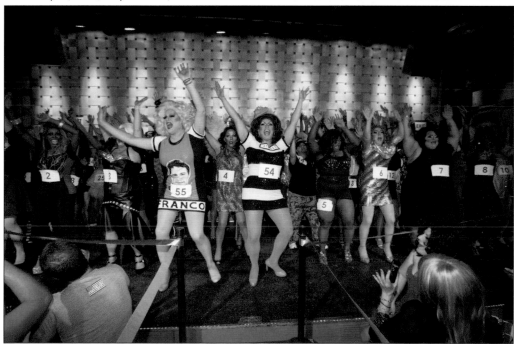

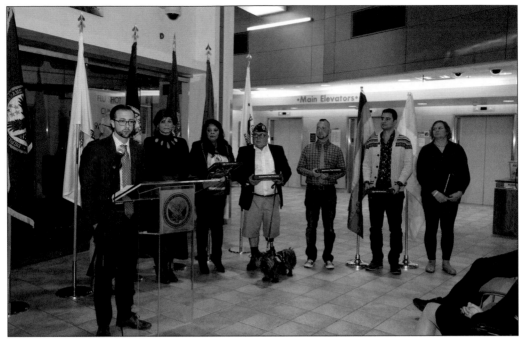

In 2014, Stonewall Columbus created LGBT Veterans Recognition Month to show appreciation for those in the LGBTQ community who have served so bravely and so selflessly. A highlight of the month is the Donald R. Hallman LGBT Veteran Recognition Awards, which are named in honor of one of the 100,000 service members who were discharged for being gay between World War II and the 2011 repeal of the military's "Don't Ask, Don't Tell" policy. So many of those discharges were deemed "dishonorable," which barred the service members from receiving veteran's benefits, prevented them from other government employment, and left them struggling with the burden of the emotional toll this forced exit imposed upon their lives. As the invitation for the event read, "We think it vitally important that the stories of those who serve are valued, respected, and, above all, heard." (Ray LaVoie.)

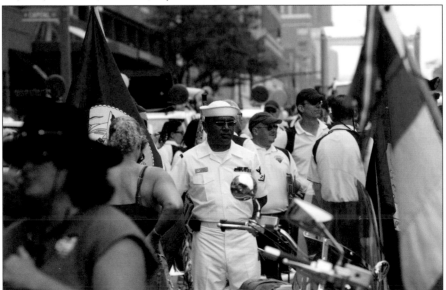

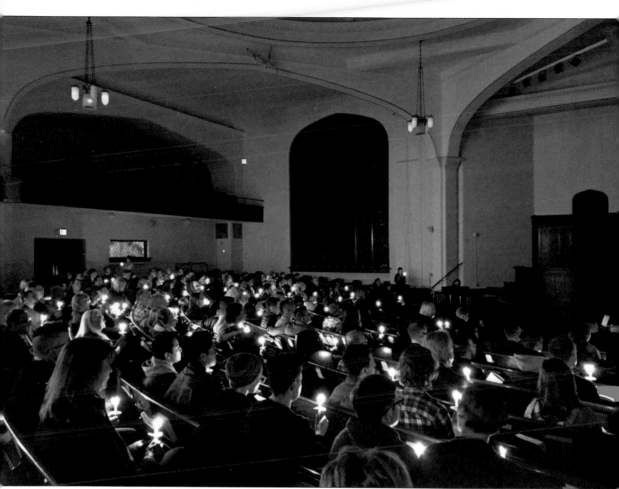

The Transgender Day of Remembrance (TDoR) is held annually as a memorial to trans-identified and gender-variant individuals who are murdered each year due to hate, transphobia, and society's strict adherence to the gender binary. The event takes place in November to honor Rita Hester, whose murder on November 28, 1998, kicked off the "Remembering Our Dead" web project and a San Francisco candlelight vigil in 1999. The Columbus observance of TDoR began in 2006 and has been held in various locations, including the King Avenue United Methodist Church, where candles have been held aloft for years. (Staley Joseph.)

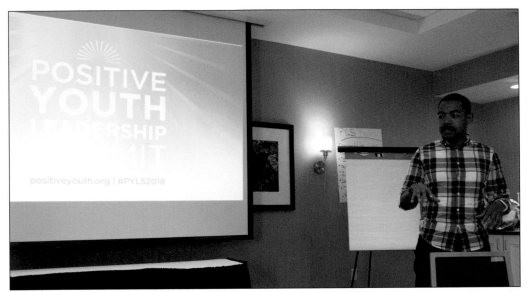

For well over a decade, HIV-positive young people from across the Midwest have been gathering for the Positive Youth Leadership Summit. Sponsored by Equitas Health, this event sets out to prepare and empower HIV-positive youth by moving past the traditional model of providing medical care and, instead, teaching them the skills to advocate for themselves and the communities around them. (Dina Michelle.)

In 2016, two events became one. The Ohio Leadership Conference on HIV/AIDS and the Central Ohio LGBTQ Health Equity Conference came together for an expanded offering called Transforming Care: Midwest Conference on LGBTQ Health Equity and HIV/AIDS. This annual event has come to be known as the most comprehensive conference on LGBTQ health equity and HIV/AIDS in the country, gathering together researchers, practitioners, activists, and community members in a space where perspectives are broadened. (Emma Parker Photography.)

Three

WE CONNECT
LGBTQ MEDIA

Community and connection don't always happen in person. They can also be effectively created via sources of media. Through newspapers, radio shows, podcasts, newsletters and television, the LGBTQ community has wielded every method at their disposal to reach every LGBTQ individual in every corner of Columbus. (Ohio History Connection.)

Single copy FREE. Multiple copies 75¢ each

news
of the Columbus Gay and Lesbian Community

AUGUST 1982 **Volume 5, Number 7**

KAPOSI'S SARCOMA HITS COLUMBUS
Gay Cancer Here

KAPOSI'S SARCOMA, a relatively rare form of cancer which has been known for some time is in Columbus. What has not been known about KS is what exactly causes it, what cures it, or why it almost exclusively hits males. In the past, the form of cancer was noted only in men over 50, without regard to their sexuality. Now, however, the disease seems to select Gay males for its targets primarily. Over 600 Gay men have died from the 'Gay Cancer' in the past two years. This is more than have died from Legionairre's Disease and Toxic Shock Syndrome combined. There are cases in which the disease has been arrested, but damages done to the body's immunity system offset such gains.

Only about 80% of those infected with Kaposi's sarcoma show active early warning signs. Purple skin lesions beginning on the lower extremities and spreading upward can indicate infection with this disease. These are malignant lesions and more than half who show this early warning sign will die within two years.

The other 20% of those who are infected with Kaposi's sarcoma will contract a rare form of pneumonia and over sixty percent of these victims will die within one year after the symptom appears.

Kaposi's sarcoma is currently classified as an AID, Acquired Immuno-deficiency disease. The growth of the disease varies from person to person. Symptoms may show up anywhere from three to thirty-six months after infection has taken place. While the cancer is growing in the body, it is attacking the body's natural defense systems, allowing other infectious agents to take hold. Many times a common cold will become pneumonia and cause death, just because the body can no longer fight off the cold virus due to the presence of as yet undetected cancer in the form of Kaposi's sarcoma.

Some researchers have suggested that amyl nitrite and butyl nitrite (poppers) can be the cause of KS, but more proof is needed to demonstrate conclusively the connection between the two. A rather high correlation does exist, however, between users of poppers and victims attacked by KS.

The Ohio State University Gay Alliance is in contact with several local doctors who have treated patients with Kaposi's sarcoma, and is establishing links with the Federal Center for Disease Control in Atlanta, in an effort to make the Gay/lesbian residents of Columbus more aware of the contagious disease now among us.

A SEMINAR open to the public has been scheduled for THURSDAY, AUGUST 5 at THE GARAGE immediately following the Stonewall meeting. The seminar is sponsored by the OSU Gay Alliance and will feature several area physicians who are familiar in their practice with the disease. Be there to learn about a drug which has stopped the disease and to learn of the possibility of participating in a test to screen Gay people for this terrible disease.

213

news

of the Columbus Gay and Lesbian Community

JULY 1980 **VOL.3 NO.6**

GAY CUBANS EXILED

The "Cuban Exile problem" includes a full barracks of Lesbians and another of Gay males. Labeled part of the "criminal element", their ID cards are stamped "DEVIANT". None of our social service agencies will handle them.

They have suffered terribly. They were even bayonetted on their way to the boats. The straight Cubans feel threatened and may kill them, fearing the "Gay presence" will make them "look bad". They suffer severely from "Oppression sickness".

Until recently, no Gay groups had been allowed to work with the Gay exiles—but the Government contacted UF-MCC as a religious non-political organization, and has certified it to work with these people. MCC is concerned that NO ONE be returned to Cuba merely because they are Gay. MCC is setting up a fact-finding commission to determine the needs and resources available. MCC will minister to them while they are in the camps and help relocate them through sponsors who will give temporary housing and jobs.

A Relief Fund has been established to aid in this and Columbus MCC will collect funds in Central Ohio. Checks should be made payable to MCC-Columbus, clearly designated for UF-MCC Relief Fund. This will be forwarded in its entirety to UF-MCC. 62% of the monies will be used for actual relief , 38% for Administration (travel, telephones, staff, etc.). Communities all over the U.S. are responding to the URGENT NEED and we feel Columbus will also. Checks /money may be given direct or mailed to MCC, Box 10009, Columbus, Ohio 43201

DEAR ANITA...

Dear Anita,

For years you have been rather occupied with other persons' personal lives. Please forgive me if I now kibitz your own just a bit.

Specifically, about your divorce: definitely no way. See Matthew 19:6, Mark 10:12, and Corinthians 7:10-11 and 27.

Of course, a person may divorce if adultery is proven(matthew 5:32)but your so-called justification is that your husband has been trying to control your ministry.

First, let us deal with your ministry.

"Let your women keep silence in the churches; for it is not permitted unto them to speak; but they are commanded to be under obedience, even as the law says. If there is anything they desire to know, let them ask their husbands at home..." (I Corinthians 14:34-35).

In reference to this, I personally have seen you several times speaking on Jerry Falwell's church program, and I think he should probably shut up too.

CONTINUED ON PAGE 54

Launching in the late 1970s, *News of the Columbus Gay and Lesbian Community* is widely regarded as Ohio's oldest gay and lesbian publication. Despite its name, the newspaper (which had more the appearance of a really thick newsletter on newsprint) featured news both local and national, alongside personals ads, movie reviews, and the regular printing of the standings in the gay bowling league. (Ohio History Connection.)

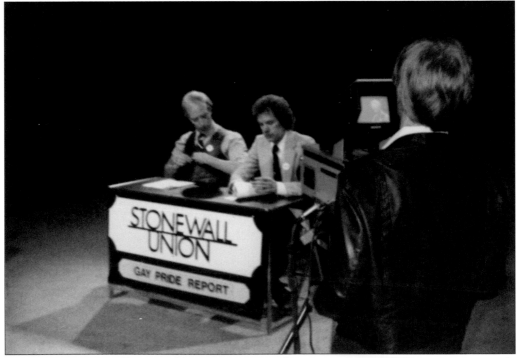

In 1982, the Stonewall Union debuted the *Gay Pride Report*. With LGBTQ issues increasingly being covered in the news and so much of the coverage being negative, the *Gay Pride Report* was designed to show television audiences that gay people were healthy, functioning, and looked just like everyone else. The show aired at 3:00 a.m. (Ohio History Connection.)

By the mid-1980s, *Stonewall Journal* had become the longest running LGBTQ newspaper in Columbus that was then in active publication. The free monthly publication was a product of Stonewall Union and was available at LGBTQ establishments or to have mailed to you in a plain, unmarked envelope. *Stonewall Journal* featured pieces connected to the organization (community calendar, event recaps, facility updates) as well as news both local and national. (Ohio History Connection.)

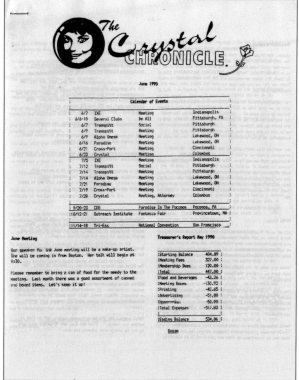

The *Crystal Chronicle* was a publication affiliated with the Crystal Club, a central Ohio support group that was originally for crossdressers but later expanded to all individuals of trans experience. The newsletter featured personal narratives from various members of the group, a multitude of tips related to wardrobe, voice, and appearance so that individuals could better "pass" for female in society-at-large, and the advertisement of upcoming meetings of the group. (Ohio History Connection.)

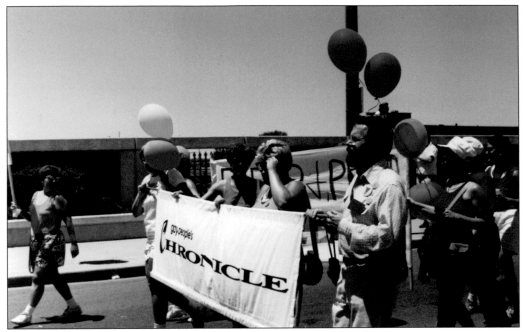

Though based out of Cleveland, *Gay People's Chronicle* regularly covered LGBTQ news and events in Columbus throughout its 30-plus-year run. The staff was an annual presence marching in Columbus Pride. Ultimately, the publication suffered the fate of countless other newspapers across the country whose advertising dollars dried up in the face of internet usage. After a remarkable run of 31 years, printing ceased on December 25, 2015. (Brian DeWitt.)

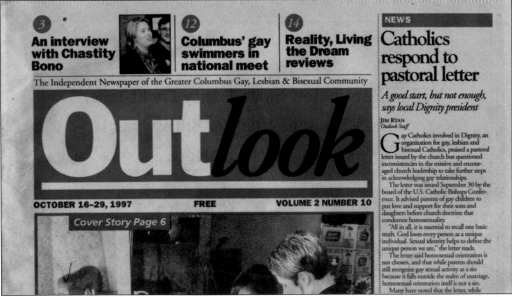

From biweekly newsprint journalism to monthly lifestyle magazine to even a brief foray into radio, *Outlook* was a part of the Columbus media landscape for decades. Though the publication often changed mastheads, formats, offices, and even the very name of the publication itself, the core of *Outlook* has always been a focus on the stories affecting the lives of the Columbus LGBTQ community. (Ohio History Connection.)

As HIV/AIDS continued to decimate the gay community, ACT UP harnessed the power of print in order to more effectively convey their message, raise awareness, and organize for future actions. ACT UP Columbus launched *Speak Up* in 1990 as a means to express their voice through a different medium, using ink as yet another means to remind the community that silence equals death. (Ohio History Connection.)

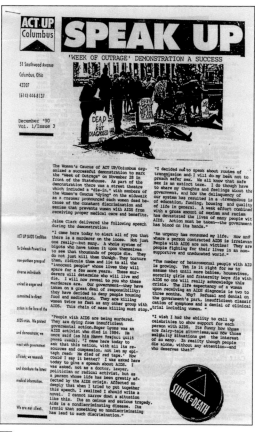

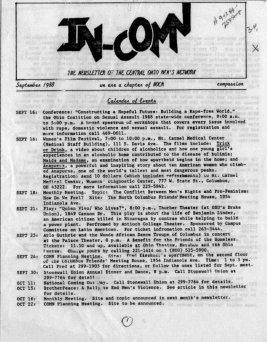

IN-COMN was a newsletter of the Central Ohio Men's Network, a chapter of the National Organization for Changing Men, which is now called the National Organization for Men Against Sexism. The publication was a reflection of pro-feminist, gay-affirming, anti-sexist views, regularly advertising events and publishing viewpoints that aligned with this philosophy. The word "compassion" was listed on the cover, which was seen as a rejection of the anti-feminist "men's rights" backlash movements that had popped up in the late 1970s. (Ohio History Connection.)

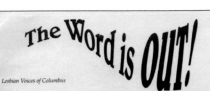

The Word is OUT was a publication that represented lesbian voices of Columbus, running for roughly a decade starting in 1991. The newsletter regularly covered various events of interest, first-person narratives, and reflections from members of the local community, spotlight profiles of various lesbians of note, community calendar, and a wealth of advertisements for local businesses, organizations, and initiatives catering to the lesbian community. (Ohio History Connection.)

Lesbian Voices of Columbus

March 1997 Volume 6 Number 11

Kings Take The Stage!

by M. Fulton

If you happened to be driving down Summit Street on the night of Valentines Day, you might have seen something unusual, a line of people waiting to get into Jacks, (also known as Summit Station). The big draw that night was the hottest new concept in lesbian entertainment to hit Columbus in a long time. Combining bands, a dj, and drag kings, the 90's lesbian version of a variety show has been born. It is a collaborative effort by three Columbus women to bring together music, dancing, and drag kings to lesbian audiences.

The entertainment can be most accurately described as a variety show. Julie Applegate, one of the founders, likes the idea of "trying to appeal to a lot of women and make a lot of people happy at once."

The idea started when Julie was offered an opportunity to dj at Jacks. Sile Singleton suggested hiring a band to perform. Ivett Domalewski thought up the idea for the drag show and

Helen Harris organized and coordinated the show itself.

These original ideas have developed into two separate identities. The first is the production company, made up of Julie and Sile, know as "Wanawake's Jules", (wanawake means women in Swahili). The other part is composed of the drag kings, known as H.I.S. Kings, which stands for the names of the 3 original kings - Helen, Ivett, and Sue Steirer.

Despite the two separate parts both groups have decided they want the events to be a showcase for women artists/bands. They also believe in being inclusive in all aspects. All shows are 18 and over, women of all shapes, shades and styles are encouraged to attend, and plans are under way to have an interpreter for the hearing impaired at future shows. In addition almost all aspects of the show are run by women, from working the door, spinning the tunes, being the mc, dancing, working the bar, and playing in the bands. Julie wants it known that "We're not trying to be seperatist, we're just trying to offer an arena where women who have these talents and interests can put them to good use." The idea is to create a place for women to do their stuff.

Reactions to the show have been very positive, especially to the drag king portions. According to Julie the first drag show "got a little crazy, there was an incident with a dildo and nudity". While there was some concern over the nudity of the first show, especially by bar management, the audience reaction has been overwhelming-

Helen Harris as Billy the Urban Cowboy!

ly positive. The high turn out shows that there is a demand for this kind of entertainment here in Columbus.

The group plans to stage another show in a couple of months. They hope to be able to move to a larger venue, so that more women are able to participate and attend. Both Wanawakes Jules and H.I.S. Kings plan to keep Jacks as their "home base", but they eventually hope to take the show on the road to other Ohio cities.

While there is a core of about 5-6 drag kings currently involved, Julie Helen, and Sile are always looking for new performers. Sile belives that doing drag is a way of "breaking lesbian stereotypes and challenging what it means to be a lesbian." Any woman who is interested in performing drag, or any band that is interested in playing, can contact Helen or Julie at 262-3125.

Sue Steirer as Tony working the crowd!

Launching in October of 2017, *PRIZM* is an LGBTQ-focused lifestyle magazine with coverage on current events, health, arts & culture, fashion, politics, news, travel, and entertainment. A monthly publication of Equitas Health, *PRIZM* boasts a circulation of 22,000 glossy units covering life both in Columbus and Ohio at large, serving to connect LGBTQ communities across the Buckeye State. (Sydney Ashbaugh and Staley Munroe.)

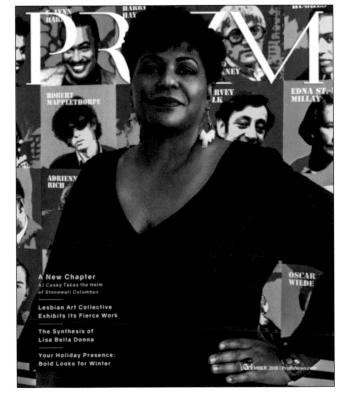

Four

WE ORGANIZE
ACTIVISM AND ISSUES

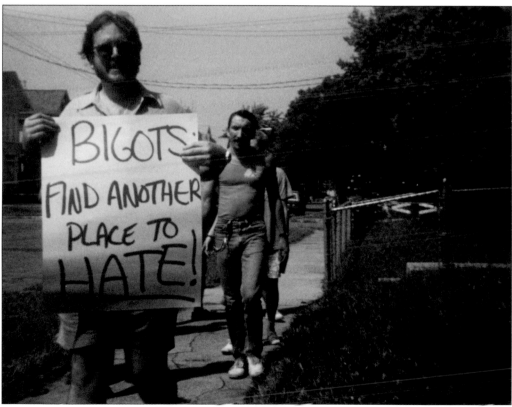

Whether responding to national events or phenomena that were uniquely more Columbus, the LGBTQ community banded together countless times over the years to protest a discriminatory action, draw attention to a lack of equality, and demand change when rights were at stake. When the inspired speech, the creative sign, or the well-crafted letter was needed, Columbus has never experienced a shortage of impassioned and brave voices ready to be heard. (Ohio History Connection.)

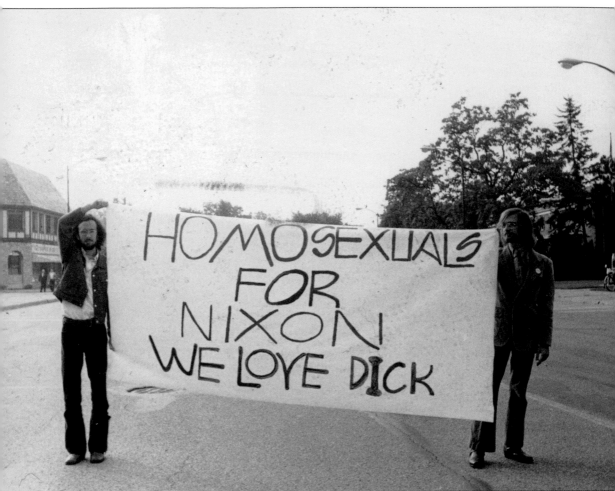

Although he once asserted that he was "the most tolerant person" of anyone in his administration on the "gay thing," Richard Nixon's views on the LGBTQ community were most definitely all over the map. He famously complained that the television show *All in the Family* "glorified homosexuality," but also asserted that gay people were born that way, a sentiment ahead of his time. A book in 2012 alleged Nixon had an ongoing same-sex affair for years, even as other reports claimed that he called gay people "ill" and that they should not be placed in high levels of government. Regardless of where he stood, he certainly had the support of some pun-loving gays, as these two Columbus men proved in 1972 with their clearly articulated banner of support. (Ohio History Connection.)

In 1971, the National Organization for Women expanded their policies to include lesbian rights, declaring "that a woman's right to her own person includes the right to define and express her own sexuality and to choose her own lifestyle." As shown in this 1980s Columbus demonstration, the fight for women's rights has been inextricably tied together with the clarion call for lesbian rights. (Ohio History Connection.)

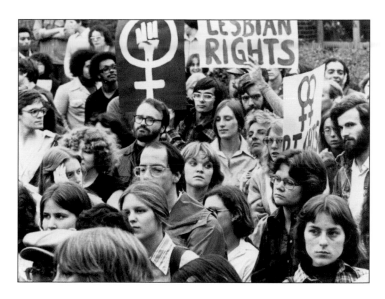

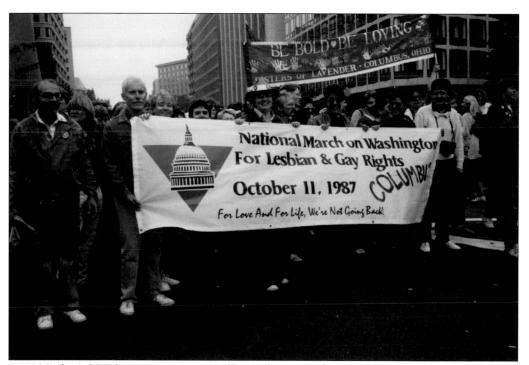

In 1986, the LGBTQ community was collectively outraged by the Supreme Court's decision in *Bowers v. Hardwick* to uphold anti-sodomy laws persecuting consenting adults in the privacy of their homes. This anger helped motivate hundreds of thousands of citizens, including a large contingent from Columbus, to attend the Second Annual March on Washington for Lesbian and Gay Rights on October 11, 1987. (Ohio History Connection.)

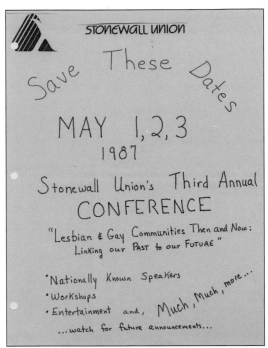

STONEWALL UNION

Save These Dates

MAY 1, 2, 3
1987

Stonewall Union's Third Annual
CONFERENCE

"Lesbian & Gay Communities Then and Now:
Linking our PAST to our FUTURE"

• Nationally Known Speakers
• Workshops
• Entertainment and, Much, Much, more...
...watch for future announcements...

In a year that marked the founding of ACT UP, the Second Annual March on Washington for Gay and Lesbian Rights, and President Reagan's very first public mention of AIDS (after a death toll in the tens of thousands), Stonewall Union held their Third Annual Conference in 1987. The theme, "Lesbian & Gay Communities Then and Now," was a reflection of the desperate need to claim a feeling of power in the face of the crisis felt throughout the LGBTQ community. (Ohio History Connection.)

When Bill Clinton met with LGBTQ advocates in Hollywood in 1991, he became the first presidential candidate to openly court the gay vote, filling the LGBTQ community with hope for an ally in the White House. Under his tenure, President Clinton signed off on "Don't Ask, Don't Tell" and the Defense of Marriage Act (DOMA), sparking protests across the country, including this one in Columbus, against a president who was not the defender of the LGBTQ community he had purported to be. (Ohio History Connection.)

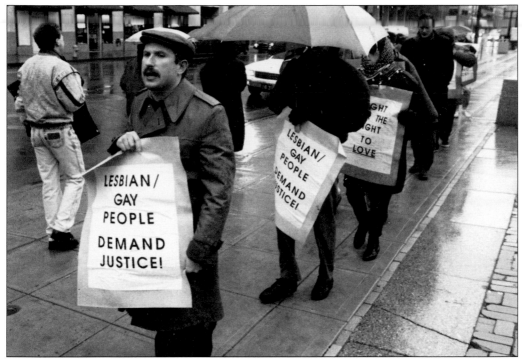

In August 1989, protesters gathered outside the city municipal building with signs in hand and voices ready to be heard. The source of their ire: the report that two gay men had been allegedly forced out of their neighborhood because of anti-gay harassment. Columbus had just passed a city ordinance that extended residential discrimination protection to include homosexuals, but this was the first instance of a case possibly being covered by this new inclusion. With signs reminding onlookers that everyone has the right to live wherever they choose, the LGBTQ community was demanding the justice owed to them under the law. (Ohio History Connection.)

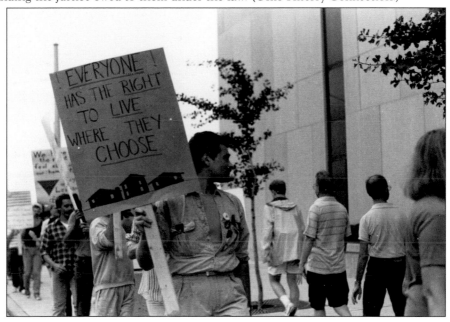

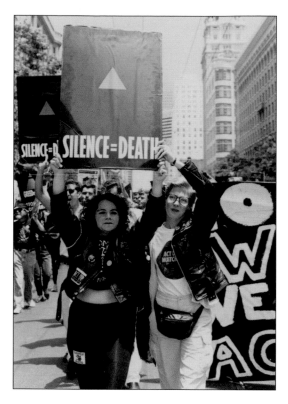

Founded in New York City in 1987, ACT UP is a diverse, nonpartisan group of individuals united in anger and committed to ending the AIDS crisis. "Silence=Death," their famous slogan, epitomizes the need for direct action to make an actual difference. The presence of the Columbus chapter of ACT UP has made itself known over the years, staging various public events to demand attention to the disease that was ravaging our community. These demonstrations included their 1991 protest outside the *Columbus Dispatch* to decry the lack of AIDS coverage by the newspaper and the die-in described on the following page. (Ohio History Connection.)

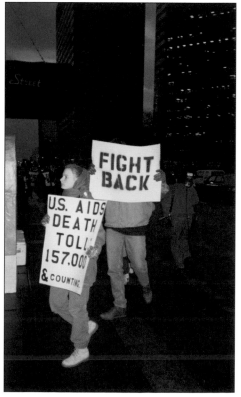

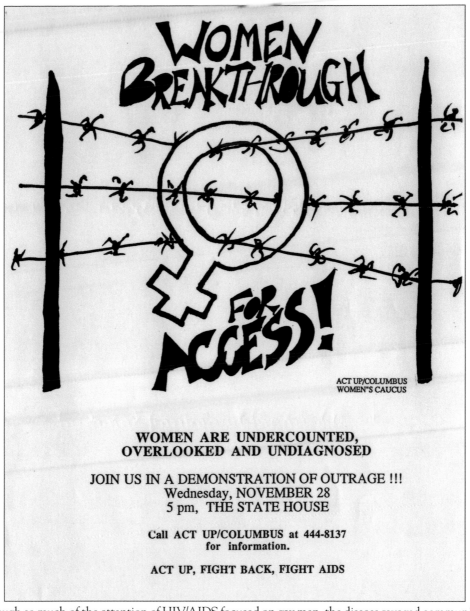

WOMEN ARE UNDERCOUNTED, OVERLOOKED AND UNDIAGNOSED

JOIN US IN A DEMONSTRATION OF OUTRAGE !!!
Wednesday, NOVEMBER 28
5 pm, THE STATE HOUSE

Call ACT UP/COLUMBUS at 444-8137
for information.

ACT UP, FIGHT BACK, FIGHT AIDS

Though so much of the attention of HIV/AIDS focused on gay men, the disease ravaged communities of women as well. ACT UP/Columbus Women's Caucus fought ceaselessly to remind their LGBTQ siblings that women were undercounted, overlooked, and undiagnosed in the face of the epidemic. On November 28, 1990, the Women's Caucus staged a "die-in," with a mock coroner pronouncing women dead on the sidewalk due to the sexism and discrimination that prevented women with AIDS from accessing the care they needed. In a speech during the demonstration, activist Jaime Clark said, "I came here today to alert all of you that there is a murderer on the loose . . . A whole system of bigots who have taken it upon themselves to see that thousands of people die . . . I will now reveal to you who these murderers are. Our government. They have taken on a great deal of responsibility; they have decided to deny people housing, food, and medication, They are killing women twice as fast as any other group with AIDS. This chain of mass killing must stop." (Ohio History Connection.)

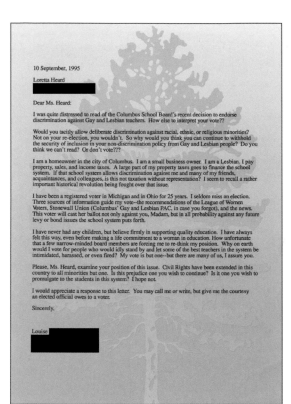

Despite Columbus Board of Education president Robert W. Teater's attempt to keep an item off of the board's agenda in October 1995, board member Mary Jo Kilroy was able to present a proposal to add two words to their policy against discrimination: sexual orientation. The vote came after spirited discussion among board members and many in attendance. "God made whites, blacks, women and men. He did not make homosexuals," said Glenn Elder, a parent and one-time school board candidate. "We don't give special privileges to someone just because they do something wrong." Mary Jo Hudson, the chairwoman of Ohioans Against Discrimination, said the change would support some of the district's "most dedicated and competent employees who also happen to be gay and lesbian." The proposed language was voted down by a 5-2 margin, prompting many letters from members of the community expressing their deep disappointment with the board and their appreciation for Kilroy. (Both, Ohio History Connection.)

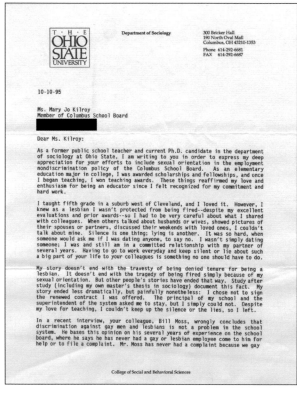

Just when you thought police raids were an abhorrent practice relegated to the annals of gay history, the LGBTQ community was alarmed in November 1997 to learn of arrests made in four different Columbus gay bars. Officially, these arrests were made for drug-related charges, but concerns were raised based on the apparent targeting of the gay bars, police conduct during the raids, and the effect of these raids on the historically fraught relationship between law enforcement and the LGBTQ community. (Ohio History Connection.)

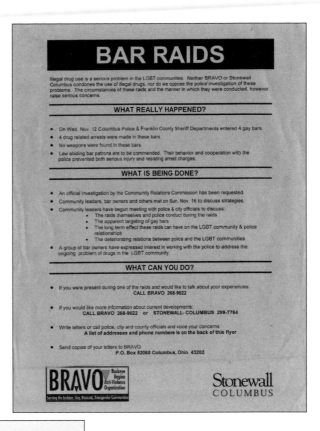

When Matthew Shepard was brutally attacked in October 1998 and left strung onto a fence to die in Laramie, Wyoming, the news captured the attention of the entire LGBTQ community. As happened across the country, a candlelight vigil was held in Columbus on the Ohio Statehouse steps, giving the community an opportunity to come together to honor the life that was needlessly lost and advocate for the hate crimes protections that desperately needed to be created. (Ohio History Connection.)

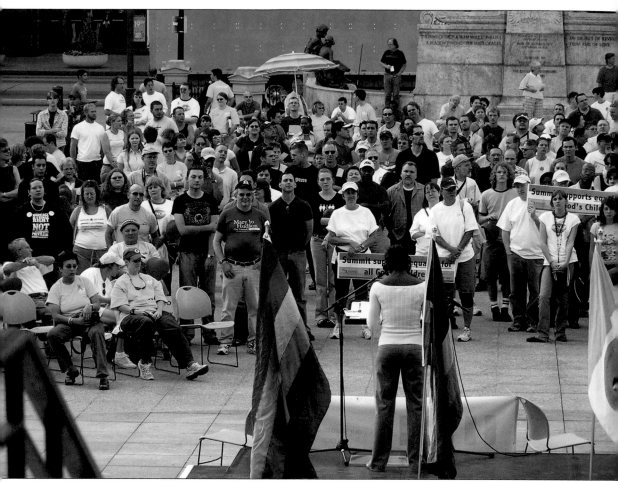

A crowd gathered from all over Ohio on October 1, 2005, to attend "Homecoming," a response to the 2004 election when voters passed Ohio's constitutional amendment banning same-sex marriage and recognition of any relationship outside opposite sexes. The rally served as Equality Ohio's first public demonstration and statement since the organization had formed in direct response to the election results. Many regarded the event as the first attempt to address LGBTQ equality as a state via a permanent organization, rather than city-by-city approach in response to a specific event that had arisen. Before the event, communities gathered for small rallies and then caravanned to Columbus for the main event. Perched in front of the statehouse, the event featured an array of speakers from across the state representing different perspectives—national leaders, straight allies, faith-based affiliates, and more—all championing a statewide nondiscrimination act and family protection. The rally concluded with all of those in attendance chanting, "Our state. Our lives. Our home." (Brian DeWitt.)

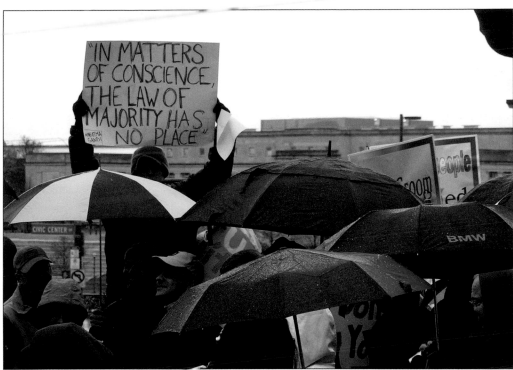

In the face of the 2008 historic election of Pres. Barack Obama, the LGBTQ community's joy was dramatically tempered by the passage of Proposition 8 by voters in California. The ballot proposition created a state constitutional amendment banning same-sex marriage. Protests were staged throughout the country, including one in Columbus on November 15th, which featured speeches and sign holders lining the streets to be seen by all passing cars. In a true display of intersectionality, the protest also featured signs bringing attention to other issues of LGBTQ rights, including racial inequality within the community. Prop 8 was ruled unconstitutional by a federal court in 2010 and by a federal appeals court in 2012. When the Supreme Court decided it would not take up the case on June 26, 2013, same-sex marriages resumed on June 28th in California for the first time in over four years. (Both, Brian DeWitt.)

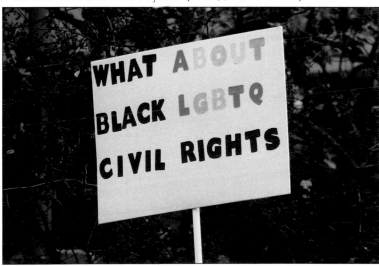

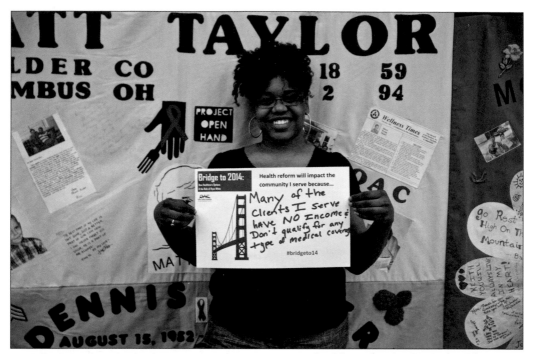

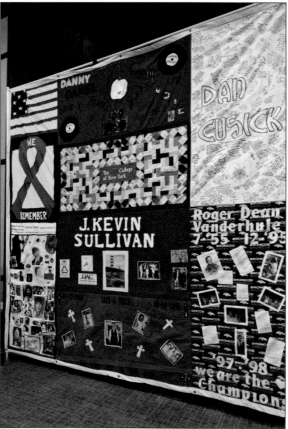

On November 21, 2013, the Ohio AIDS Coalition gathered together over 200 healthcare and LGBTQ professionals for the "Building the Bridge to 2014" conference. The focus of the gathering was a deep dive into the topic of healthcare reform, specifically how potential changes to legislation like the Ryan White Care Act would affect vulnerable populations and how those assembled could better advocate for their clients. The conference was also notable for its backdrop: six panels of the NAMES Project AIDS Memorial Quilt. Cleve Jones organized the creation of the quilt in 1985 as a memorial for those who had died of AIDS. He called it "a statement of hope and remembrance, a symbol of national unity, and a promise of love." (Both, Equitas Health.)

Barely two weeks after the US Supreme Court handed down a decision that made marriage equality the law of Ohio and the entire country, Columbus mayor Michael B. Coleman commemorated the historic occasion in grand fashion for an event called "Vowed and Proud." On July 11, 2015, Mayor Coleman, who had long been an advocate for gay rights, married 13 couples at Portman Plaza at city hall, the first same-sex weddings he had officiated since the landmark ruling. In the nine-minute ceremony, Mayor Coleman led the couples through some traditional vows, had them exchange rings, signed all of their marriage licenses, and delivered a few remarks before rainbow cake was enjoyed by the hundreds in attendance. (Both, Emma Parker Photography.)

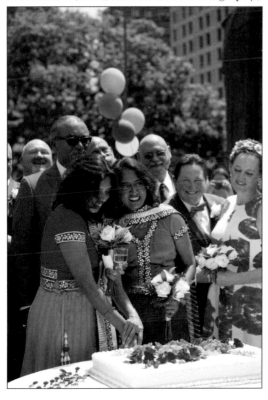

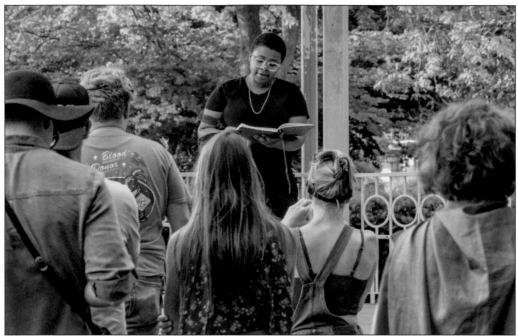

On June 12, 2016, the LGBTQ and ally community was devastated to learn of the mass shooting at Pulse, an LGBTQ nightclub in Orlando, Florida, where 49 people were murdered and 58 injured, so many of them Latinx. The tragedy prompted vigils across the country, with the devastation, outrage, and grief providing a stark contrast of emotions to those normally experienced during Pride Month. With Columbus Pride taking place only a few days later, LGBTQ leaders in Columbus encouraged people to come out to partake in the festivities while still remaining vigilant for anything out of the ordinary. One year after the terrorist attack, members of the Columbus community gathered together for a vigil to remember those who were lost and publicly express their resolve for the day when these threats are not a part of the fabric of their existence. (Both, Ralph Orr.)

Despite the ubiquitous narrative that being gay and holding a strong faith-based identity are mutually exclusive, the assertion could not be further from the truth. In fact, Columbus houses of worship and faith organizations have been there every step of the way supporting the LGBTQ community: marching in Columbus Pride, standing next to them at protests with placards aloft, and always attending to the spiritual health and well-being of everyone in Columbus so desperately fighting for equality. (Ohio History Connection.)

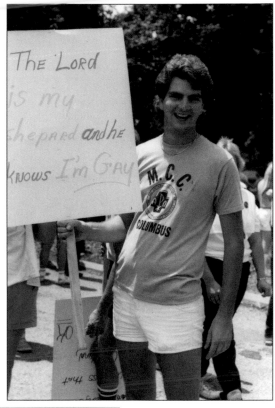

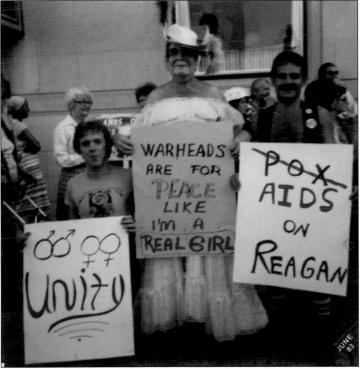

You would be hard-pressed to find a community who values intersectionality more than the LGBTQ community, particularly when it comes to activism. With so many issues to resolve in society coupled with no shortage of passion, it should come as no surprise that even a protest against Pres. Ronald Regan in the 1980s featured a variety of approaches to the issues of the day, from nuclear proliferation to calls for more unity to the HIV/AIDS epidemic that was ravaging the community. (Ohio History Connection.)

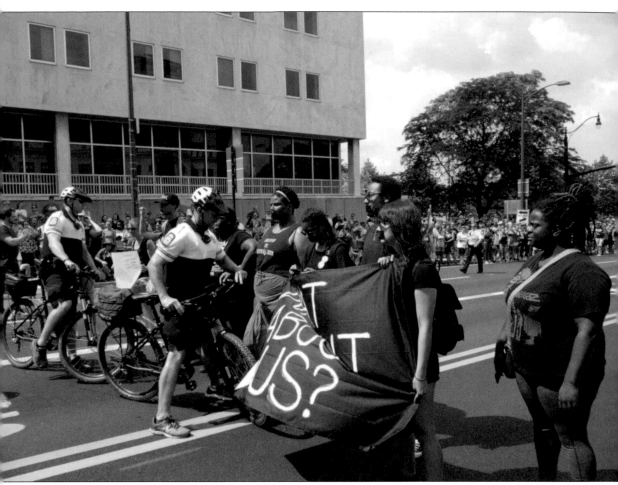

At Columbus Pride 2017, a group of black queer and trans protesters and their allies gathered behind a banner that read, "What About Us?" with the intent of silently blocking the parade for seven minutes to protest the previous day's acquittal of Philando Castile's murderer in Minneapolis and to raise awareness of the violence against and erasure of black and brown queer and trans people. Within 45 seconds, the protesters were confronted by police who used their bikes to forcefully push the protesters back, sprayed mace at them, tackled some of the protesters to the hot concrete, and surrounded them with cops on horseback. Four of the protesters were arrested and charged with disorderly conduct, failure to comply with a police officer's order, causing harm to a police officer and resisting arrest. One was charged with a felony of aggravated robbery for allegedly attempting to take an officer's weapon. These four became known as the #BlackPride4. (Torin Jacobs and Activist Arts.)

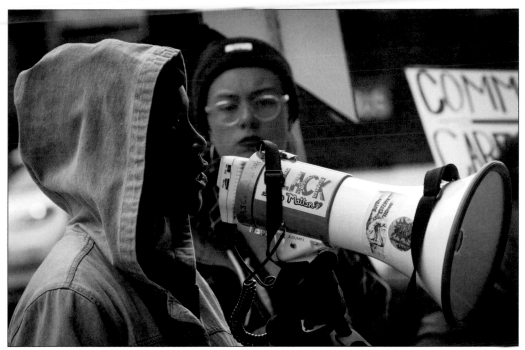

The arrest of the #BlackPride4 galvanized the Columbus community in myriad ways. A prime source of ire was directed at Stonewall Columbus, which was criticized for not showing more support, as evidenced by their not issuing an official statement until six days after Pride (their own event), that statement not including language that condemned the actions of the police, and their failure to provide legal or financial support to those arrested. Numerous Stonewall staff and board members resigned, including the Pride coordinator and 16 Pride Planning Committee members. On November 7, 2017, supporters of the #BlackPride4 marched from city prosecutor Richard Pfeiffer's office to Franklin County prosecutor Ron O'Brien's office to drop off a petition demanding that the charges be dropped and to reclaim space for black and brown queer and trans people. On March 13, 2018, three of the #BlackPride4 were sentenced with fines, community service and probationary periods and no jail time. On June 18, 2018, more than a year after the arrests, the fourth protester was given probation and community service. The felony charge had been dropped. (Both, Ralph Orr.)

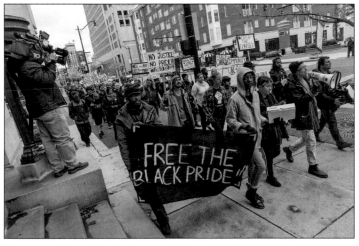

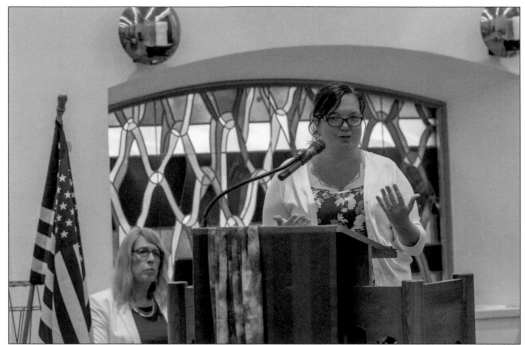

When President Trump tweeted on July 26, 2017, his intention to bar the service of transgender individuals within the US Armed Forces, members of the Central Ohio transgender community and their allies decided to come together to counter Trump's blatant discriminatory exclusion. On August 11th, they held a Transgender Military Recognition Night at Summit on 16th United Methodist Church in Columbus. The evening featured LGBTQ veteran care coordinator Jessica Holman and several trans veterans., and served to honor current trans members of the military and trans veterans by giving the Columbus community an opportunity to celebrate our trans siblings' bravery, sacrifices, and freedom to serve. (Btoh, Ralph Orr.)

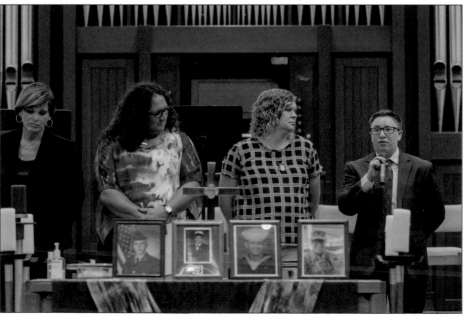

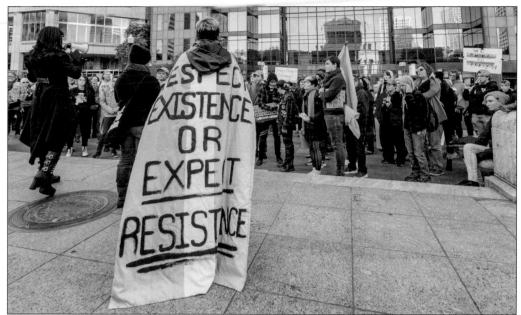

Despite his professed support for the LGBTQ community by holding a rainbow flag upside down during his election campaign, President Trump wasted no time in rolling back protections for the trans community as soon as he took office. These actions included erasing recommendations for supporting transgender federal workers on government websites, withdrawing guidance explaining how schools must protect transgender students, and doggedly pursuing the exclusion and removal of transgender military service members. On October 21, 2018, the *New York Times* reported that the Trump administration was considering legally redefining gender as "immutable biological traits identifiable by our before birth," effectively attempting to erase our transgender siblings out of existence. On November 7th, the Columbus community gathered together for "We Won't Be Erased—Rally for Trans Visibility," a rally at the statehouse followed by a march to Goodale Park. Their stated goal was to issue a clarion call for Ohio State government officials "to both support and protect us from this federal administration's jackboot trampling of our rights." (Both, Ralph Orr.)

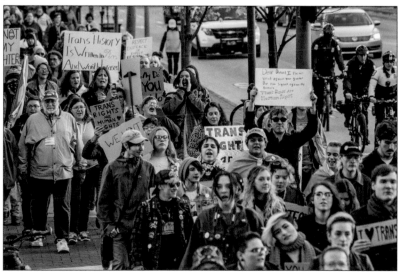

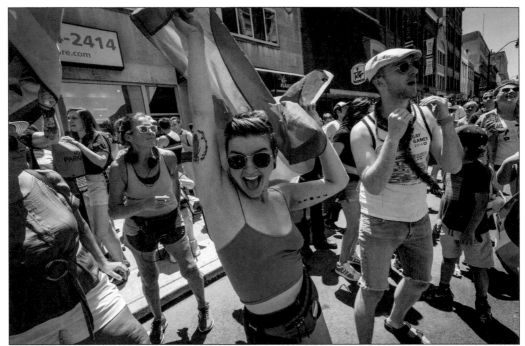

When Vice Pres. Mike Pence came to Columbus on June 15, 2018, to speak at America First Issues, a pro-Trump nonprofit, his visit coincided with the start of Columbus Pride. In honor of well-established track record of anti-LGBTQ legislation and rhetoric as both vice president and former governor of Indiana, the Columbus LGBTQ community welcomed him in the most appropriate way possible: with the "Welcome Mike Pence! Big LGBTQ Dance Party!" Revelers gathered outside the Renaissance Hotel, where Pence was set to speak, and danced away the afternoon outside as he delivered remarks inside. The line-up included a full roster of drag queens, DJs, and a Mike Pence-look-alike—at least, it was assumed he was a look-alike. (Both, Ralph Orr.)

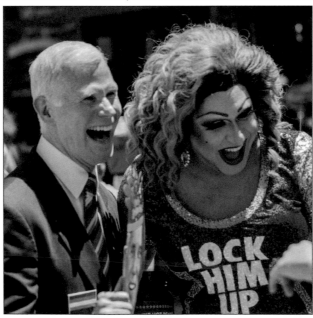

Five

WE MARCH
PRIDE CELEBRATIONS

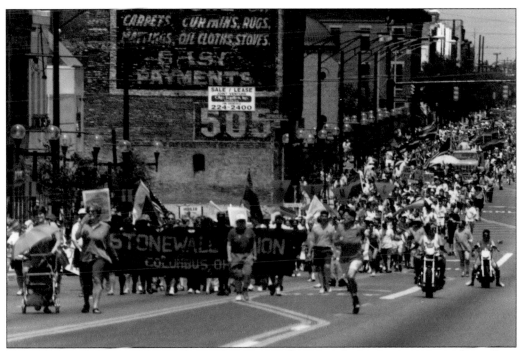

Columbus Pride has seen quite the evolution over the years: from a ragtag group of marchers wishing to remain anonymous to one of the largest celebrations in the Midwest to a recent reframing of Pride for our siblings of color. No matter the year or the type of event, June always brings with it the opportunity for individuals to stand shoulder-to-shoulder and be who they truly are. (Brian DeWitt.)

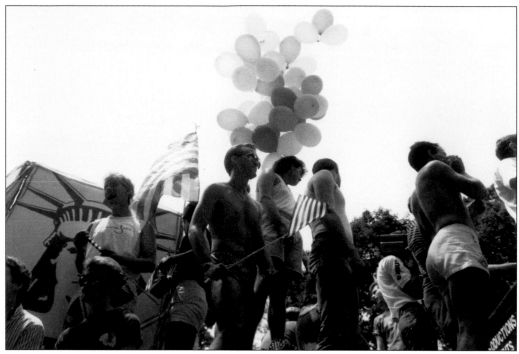

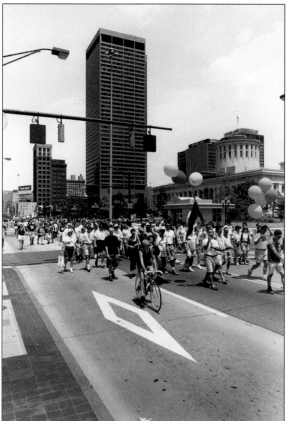

When did Columbus Pride start? Well, the answer depends on who is asked. Some would argue that the first parade was in 1981, when 200 people marched from Ohio State University to the Ohio Statehouse. Those marchers, some with bags on their heads to keep from being recognized, were commemorating the Stonewall Inn uprising of 1969, which inspired the Christopher Street Liberation Day in 1970, the first LGBT Pride march in American history. Others would argue that the first real Columbus Pride was in 1982, when 500 marchers were organized by Stonewall Union in what was officially labeled the Gay Pride Parade. Regardless of which side of the 1981 vs. 1982 debate one stands, all can agree that there are so many LGBTQ elders to thank for what is now enjoyed almost 40 years later. (Both, Ohio History Connection.)

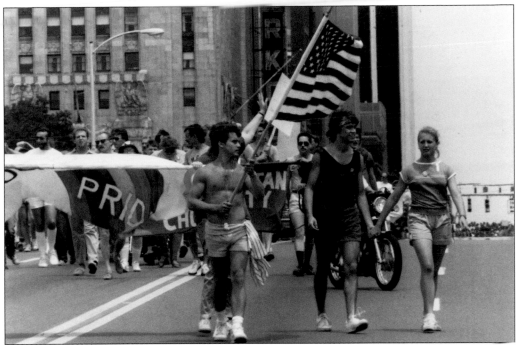

The numbers tell quite the story for Columbus Pride; 200 in 1981 more than doubled to 500 in 1982, which doubled again to 1,000 in 1983. An estimated 4,000 marchers proudly marched the streets in 1984, and that number swelled to 6,000 in 1985. What quickly became clear in these early years was that these were not just attendees from throughout Columbus, nor even solely from Ohio. People were coming from all over the country to partake in the biggest Midwest Pride festival second only to Chicago. Even that silver-medal status does not feel all that permanent, as 2018's Columbus Pride drew 10,000 marchers and an estimated 500,000-plus spectators celebrating together. If there is power in numbers, Columbus Pride is just plain mighty. (Above, Ohio History Connection; below, Brian DeWitt.)

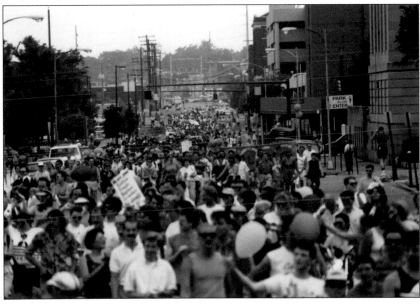

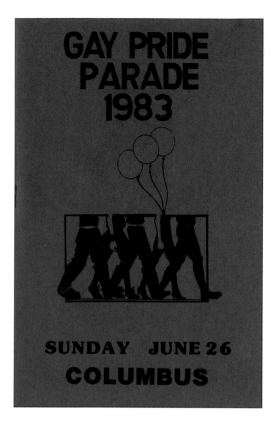

What is in a name? Over the years, the actual name of the event has changed quite a few times: Gay Pride Parade, Ohio and Michigan Lesbian and Gay Pride Parade, Midwest Gay and Lesbian Freedom Parade, Columbus Pride Festival and Parade. The evolution of the moniker was both external and internal. On the one hand, the changes mirrored the ever-evolving national sentiments about the LGBTQ community. On the other, so too were the name changes a reflection of the annually-more-realized power of identifying as LGBTQ in society for the LGBTQ population themselves. Regardless of what it is called, a Pride in Columbus by any other name still does indeed smell as sweet. (Both, Ohio History Connection.)

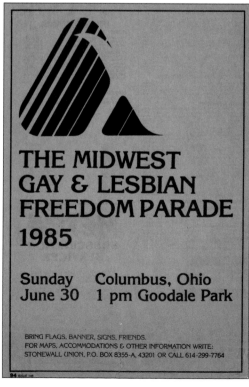

In 1988, Stonewall Columbus sponsored the March on the Midwest in the Ohio capital. In a letter urging participation, organizers wrote, "For the seventh year in a row, lesbians, gays, and their supporters will take to the streets of Columbus, Ohio demanding what is rightfully ours—civil rights. We would like to invite you, your organization or group to march with us to demonstrate the collective power of the Midwestern Lesbian/Gay Community . . . Remember, we must stand together as one united force that demands to be recognized and through your participation in this March, we can present that very fact." The event featured representation from all over the Buckeye State, from candidates for city and state offices to a special performance of the Cleveland City Country Dancers. (Both, Special Collections, Michael Schwartz Library at Cleveland State University.)

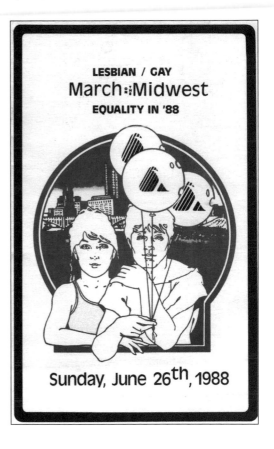

LESBIAN / GAY
March ⊞ Midwest
EQUALITY IN '88

Sunday, June 26th, 1988

The RALLY!

SUE FINK!	EMCEE
CAROL COHAN	GREETING. Executive Director, Stonewall Union
BUCK HARRIS	GREETINGS FROM THE GOVERNOR RICHARD F. CELESTE Gay Health Consultant, Ohio Department of Health
Jerry Hammond	President, Columbus City Council.
Roxanne Qualls	Candidate for City Council, Cincinnati.
Rick Vaughan	President, Stonewall, Cincinnati.
Rick Wallace	Board Member, Michigan Organization for Human Rights.
Gene Witts	Eleanor Roosevelt Gay Democratic Club, Cleveland.
Gary Newbold	Republican candidate for state representative.
TIM MAINS	KEYNOTE ADDRESS Openly Gay member, Rochester (NY) City Council.
Greg Merlin	Mr. Gay Columbus.
Mike Gelpi	Independent candidate for U.S. House of Representatives.
Kate Kitchen	Board Member, Columbus AIDS Task Force
Dan Downing	Coordinator, Ohio AIDS Hotline.
Liselotte Sherwood	Parents and Friends of Lesbians and Gays.
JERRY BUNGE	CLOSING REMARKS. President of Board, Stonewall Union
CATF	Memorial
Closing Song	"Singing For Our Lives", Holly Near.

SPECIAL DEMONSTRATION
Cleveland City Country Dancers

ASL Interpreters: Jay Imbody and Jean Stuntz

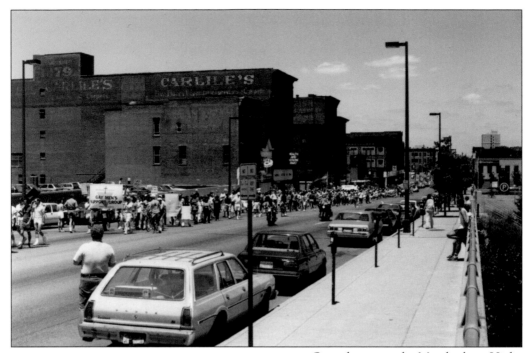

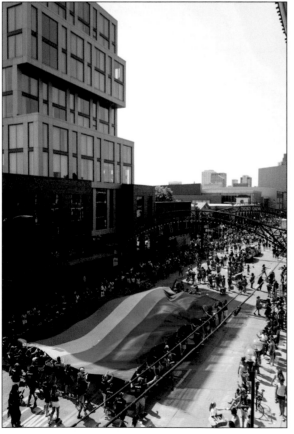

Over the years, the March along High Street has become iconic. Though the motivation to be visible binds together all those have walked proudly down that street over the decades, the physical landscape surrounding the marchers has changed dramatically over the years. Squat storefronts have given way to glass-walled luxury apartments. Abandoned parking lots have become restaurants proudly flying the rainbow flag outside their door. Even the street lamps look markedly different as they frame the assembled crowds year after year. And still, the floats roll forward, the dykes ride their bikes, the Flaggots launch their flags, and the many cheering onlookers come together right there on an ever-changing street with an unchanging pride. (Above, Brian DeWitt; left, Emma Parker Photography.)

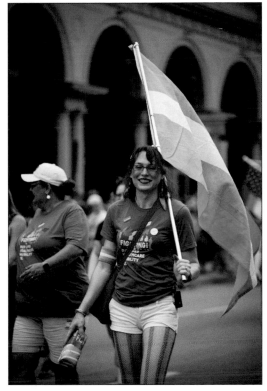

One of the evolving facets of Pride is the proliferation of myriad flags representing a range of identities within the LGBTQ spectrum. The transgender community flag, designed by Monica Helms in 1999, is made up of five horizontal stripes: two light blue, two pink, and one white in the center. The colors symbolize the traditional color for baby boys (blue), baby girls (pink) and white for people who don't identify with either. The other example is a riff on the rainbow flag designed by Gilbert Baker for the 1978 San Francisco Gay Freedom Celebration, but with an abstract drawing on it to symbolize pride in identifying as a plus-sized member of the LGBTQ community. (Right, Emma Parker Photography; below, Brian DeWitt.)

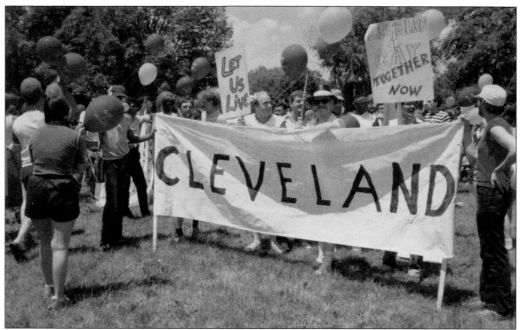

Throughout its history, Columbus Pride provided a space not just for residents of the city but also for individuals from all over Ohio to come display pride in their lives, their unity, and, of course, their home city. For some, Columbus Pride represented a chance to participate in an event simply not held in their local community. For others, Pride provided LGBTQ Ohioans with the opportunity to openly walk down the street holding a partner's hand, something many did not feel comfortable doing in their home city for fear of their identity being revealed to loved ones or employers. Regardless of the reason, Columbus Pride has come to symbolize an entire state coming together as a community far beyond the boundaries of the state capital. (Above, Robert Downing; below, Brian DeWitt.)

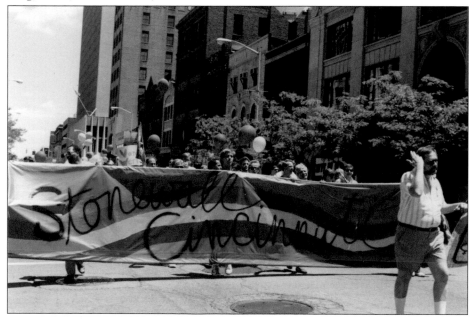

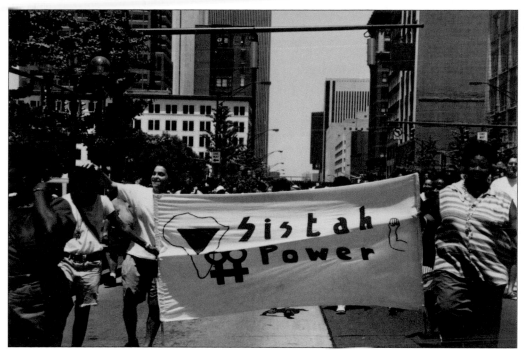

When Craig Rodwell, Fred Sargeant, Linda Rhodes, and Ellen Boroidy attended a regional homophile conference in 1969, they proposed a radical idea: replace the Fourth of July "Annual Reminder" pickets with a full-scale march in New York City one year after the Stonewall Riots. The "Christopher Street Liberation Day" was a departure from what had been done before, ditching the staid, wardrobe-restricted events (men in jackets and ties and women in dresses) with a freer gathering with no age or clothing restrictions. The goal was to publicly reclaim the power that had been taken away from the LGBTQ community when the police raided the bar at 51–53 Christopher Street. Since then, parades and marches across the country have existed as an annual exercise to display pride and, yes, power. Columbus is certainly no exception. (Both, Ohio History Connection.)

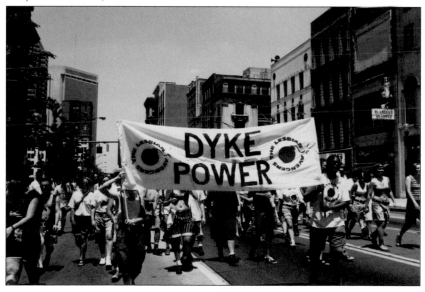

From go-go boys dancing on speakers blaring a dance groove, to their deaf LGBTQ siblings signing and waving to the crowd underneath a rainbow balloon arch, to even George Takei waving to the crowd on a green carpet in front of a huge replica of our planet Earth, floats have long been a highlight of Columbus Pride. What began decades ago as a few streamers on a platform has evolved into distinctly more elaborate productions. Although the decoration of the floats is entirely up to those registering them, participants are highly encouraged to "make a positive statement appropriate to the day's event." (Both, Emma Parker Photography.)

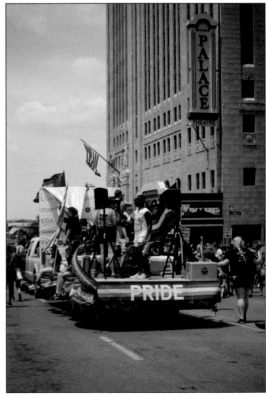

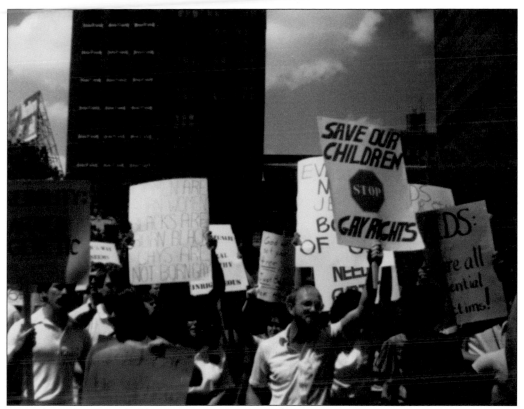

From the isolated sign holder to the occasional Westboro Baptist Church affiliate, the appearance of some scattered protesters at Columbus Pride is as reliable as the rainbow balloons flying above the streets. There has never been a time since the LGBTQ community first marched the streets where these protesters have not been wholly outnumbered by celebrants, a ratio that has only become more disparate in numbers as the years march on. Still, these lone wolves continue to show up with their increasingly forlorn signs, providing an annual opportunity for the LGBTQ community to shower them with love in the face of whatever it is the protesters are trying to bring to the festivities. (Above, Ohio History Connection; below, Brian DeWitt.)

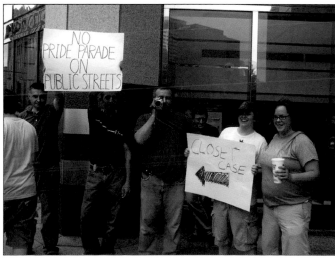

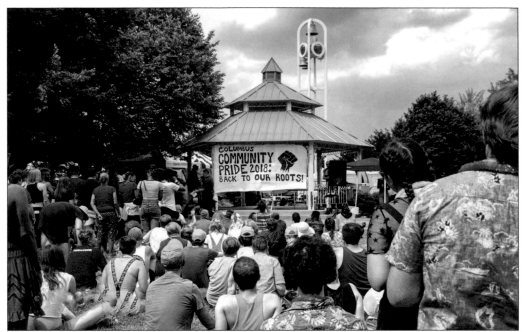

In solidarity with the initial message of #BlackPride4 to bring public attention to the lack of safe spaces for black and brown LGBTQIA+ individuals within the larger LGBTQIA+ community, Black Queer & Intersectional Columbus organized "Columbus Community Pride: Back to Our Roots" in 2018. The week of programming included a kick-off party, a film screening, a zine release party/cookout, and a community art collage dedicated to Marsha P. Johnson, and culminated in the Community Pride Festival, featuring performances and visual art by queer and trans artists of color, a community resource fair, POC-owned food trucks, and a whole lot of celebration, creativity, and joy. (Both, Katie Forbes of KR Photography.)

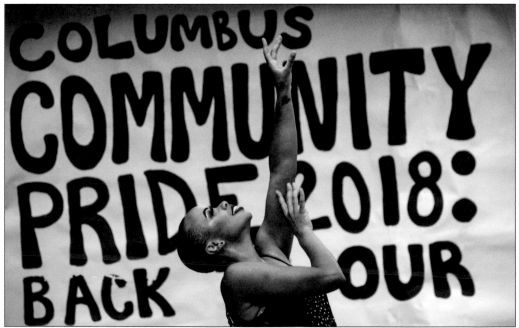

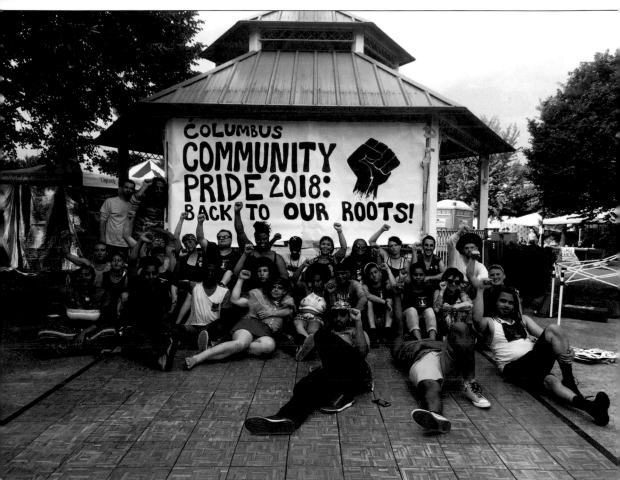

Columbus Community Pride was far more than just a party. After multiple conversations and meetings with community members, organizers developed three central issues that inform and are informed by every aspect of the event: (1) we center queer, trans, and intersex people of color and other marginalized communities, (2) we condemn all aspects of state-sanctioned violence, including but not limited to police brutality, the prison industrial complex, job insecurity, food insecurity, unfair working conditions, and sexual assault, and (3) we support grassroots social justice work and community advocacy over money-hungry corporations. By all accounts, Columbus Community Pride was an inspiring success, and plans are in effect to organize the event for 2019. (Ariana Steele.)

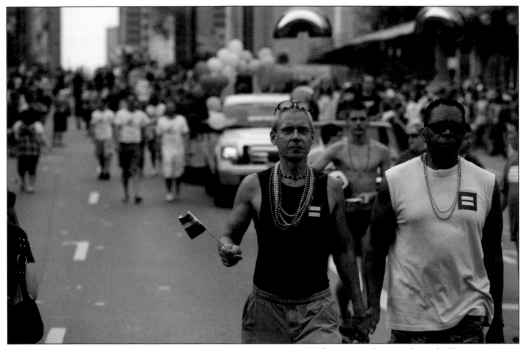

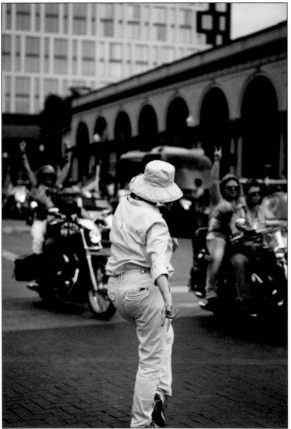

Take away the rainbow balloons. Subtract both the stage and drag queens performing on top of it. Get rid of the vendors, the beer tent, and the free merchandise from the corporate sponsors. What is left are the people, and the people alone will always be enough to constitute Pride in Columbus. Over the years, the LGBTQ community in Columbus has been through so much: rights granted, rights taken away, celebrations, setbacks, and everything in between. Through it all, LGBTQ Columbus neighbors have shown up in force, as individuals expressing their authentic selves and as a community that stands (and dances) stronger together. (Above, Ray LaVoie; left, Emma Parker Photography.)

About the
Organizations

Established in 1885, the Ohio History Connection is a
public history organization dedicated to preserving and
sharing Ohio stories. Its mission is to spark discovery
of Ohio stories. Embrace the present, share the past,
and transform the future. Through their work, they
manage more than 50 historic sites and museums across
Ohio; administer the state historic preservation office
that helps preserve historic places in Ohio; provide
education and outreach services that support students,
teachers, local history groups and communities in
Ohio; and care for the state's collections and archives
and share the stories of Ohio and Ohioans.

The Ohio History Connection's Gay Ohio History Initiative
(GOHI) works to preserve, archive, and curate the history
and culture of LGBTQ citizens of Ohio, to document and
share these stories with all Ohioans, and create opportunities
for understanding the past in order to build a better future.
The Ohio History Connection has been collecting objects
and archival materials from the LGBTQ community since
the early 1980s. For more information on this initiative
(including how to contribute), visit ohiohistory.org/gohi.

DISCOVER THOUSANDS OF LOCAL HISTORY BOOKS FEATURING MILLIONS OF VINTAGE IMAGES

Arcadia Publishing, the leading local history publisher in the United States, is committed to making history accessible and meaningful through publishing books that celebrate and preserve the heritage of America's people and places.

Find more books like this at
www.arcadiapublishing.com

Search for your hometown history, your old stomping grounds, and even your favorite sports team.